IMAGES
of America

BUCKEYE LAKE

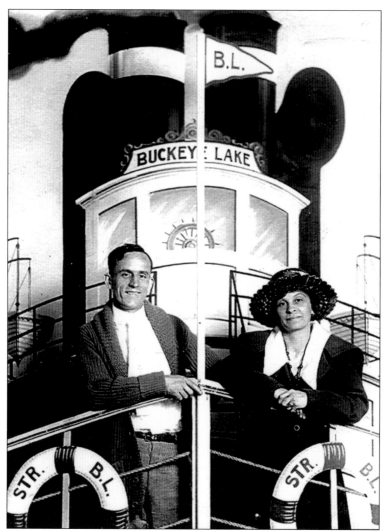

CHAUNCEY AND MABEL BROCKWAY, BUCKEYE LAKE PARK. Author Chance Brockway's mother and father took him to Buckeye Lake Park before he was born. This photograph was dated June 30, 1918, and he was born October 21, 1918. His mother, Clara Mabel Christy, was born in Canton, Ohio. His father, Chauncey Whitney Brockway, was born in Schenectady, New York. They were married March 13, 1911. His mother worked at Meyers Lake Park, and his father traveled with Al G. Fields's Minstrel Show. His specialty was a tap-dancing routine called "soft shoe," where sand was spread on the floor for a soft sound. He also marched in the New Year's Mardi Gras parades as a drummer. His parents settled in Columbus, Ohio, where his father worked for Bott Brothers Restaurant (later the Clock Restaurant) on North High Street. Bott Brothers's main business was selling pool tables, and his father became quite adept at playing pool and managing restaurants. His parents then moved to Buckeye Lake in 1918, where their house at 327 Front Street was built by Simpson and Sons of Newark at a cost of $975. His father owned the pool room in the park and managed the food concessions, including the largest sit-down restaurant in the park, the Lilac Room. The park belonged to the Columbus, Buckeye Lake and Newark Traction Company, who purchased the property from the Bounds and Swick families. The Dell Fisher Boat Line Company held a lease to waterfront property from Picnic Point to property adjacent to the Hotel Glass.

IMAGES
of America

BUCKEYE LAKE

Chance Brockway

On the cover: This c. 1900 photograph shows a Dell Fisher Boat Line Company steam-powered passenger boat named *Ada*.

This book is dedicated to all the people who ever worked at
Buckeye Lake Park, selling tickets, operating rides, serving food,
scheduling bands, directing traffic, working as security, or working on
maintenance of equipment. They gave us many years of enjoyment.
Thanks for the great memories.

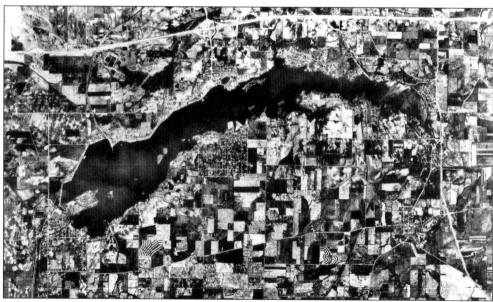

BUCKEYE LAKE AREA. This is an aerial view of Buckeye Lake.

CONTENTS

ACKNOWLEDGMENTS

I would like to acknowledge the memory of my good friends Dr. Milton B. Troutman, author of the book *Birds of Buckeye Lake*, and Russell Walters and Doris Holtsberry, two members of the original Buckeye Lake Historical Society. Thanks also to William E. Davis, a historian whose mother owned a cottage on Crane Lake in 1904. Thanks to Sam Roshon, employee of the Columbus Public Library, whose suggestion over a period of 30 years that I write a book about Buckeye Lake has finally been accomplished. Special thanks to my daughter Sondra Brockway Gartner. Without her help, none of this would have been possible. Thanks also to Arcadia Publishing, who has over 3,000 titles in their Images of America series. Profits from this book will go to the Greater Buckeye Lake Historical Society endowment fund.

—Chance Brockway

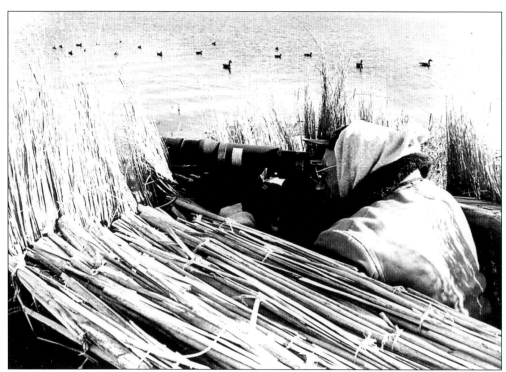

DR. MILTON B. TROUTMAN. Dr. Troutman, professor emeritus of zoology at Ohio State University, is seen in a duck blind with his ever-present camera, photographing wild life on Buckeye Lake.

6

INTRODUCTION

How well do you remember Buckeye Lake Park? The years between 1925 and 1960 provided to our parents, our generation, and our children a great amusement park known as "the Playground of Ohio." Who could ever forget the thrilling rides on the roller coaster also called "the Dips," the merry-go-round, or silver airplanes that flew over the midway? The Dodgem ride gave a chance to bump head-on with friends. There was the beautiful Crystal Ballroom where we enjoyed dancing to many big name bands, such as Jimmy and Tommy Dorsey, Sammy Kaye, Woody Herman, and Kaye Keyser. The Crystal Swimming Pool was down below. The pool was open until late at night, and swimmers could be watched from above by standing behind the bandstand. Along the lakeshore were the boat lines with shiny speedboats named *Morning Star* and *Evening Star* ready for rides up and down the lake. These were especially thrilling to young couples who rode in the rear seat and watched the high waves go by both sides of the boat. On the midway were games of chance, skee ball, and other games including Bingo and Fascination.

Each summer families and other groups would schedule vacations here in the cottages to enjoy the skating rink, swimming and dancing, and boat rides at the park. On the Fourth of July it seemed the whole world came to Buckeye Lake Park. The highway entering the village would be packed with cars parked on every piece of open ground and more than a few yards and driveways. The smell of cotton candy, roasted peanuts, caramel corn, french fries with salt and vinegar, and other delicacies floated over the air. Children ran with whoops of laughter and joy, and even the parents became children again for a day, as the trapeze artists in the center of the park entertained to shouts of amazement. As the sun set over the lake and the lights of the boats looked like a million fireflies on the water, the night would be brightly lit by the explosions of the best fireworks ever seen.

While we enjoyed the park, the entertainment, and the magical summer nights it provided, we had little idea that it would not last forever. But as most things in life, it had its time, and now the only physical reminders of its once golden days are the Buckeye Lake State Park with its boat ramps and the fountain, which is still located in the center of the park. Even though the physical park is gone, it still lives in the collection of photographs that Chance Brockway has presented in this book.

—Dale McFarland
Jacksontown resident

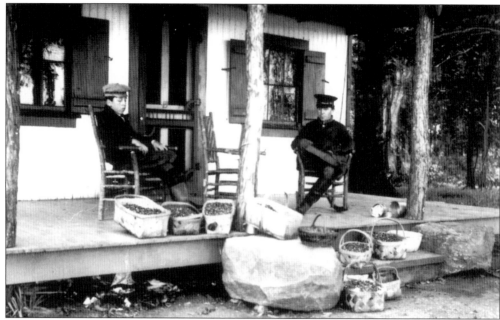

HAYNES FAMILY'S SUMMER COTTAGE. Haynes brothers are seen around 1910 seated on the porch of the Haynes family's summer cottage with nine baskets of cranberries, which they have just picked from Cranberry Marsh.

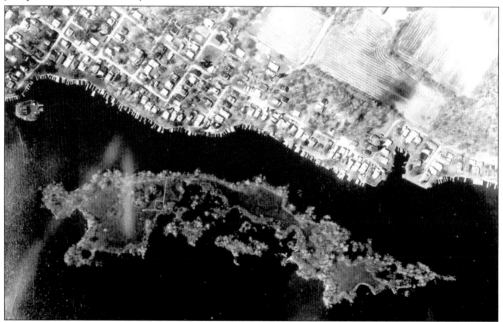

THE BIG SWAMP. On July 4, 1825, work began on the "Big Swamp," part of the pre-glacial Newark River. A reservoir was built to lift canal craft over the crest between the Scioto and Muskingum watershed for the Ohio-Erie Canal System. Cranberry Island survived as a 45-acre island. By the time it was dedicated as Cranberry Bog State Nature Preserve in 1972, only 19 acres remained of the island. The bog island is decaying, and only about 10 acres exist today with many interesting and rare plants. The area at the top of the photograph is the Bounds Addition.

One

THE ARTIFICIAL LAKE
AND OHIO CANAL

In order to provide interconnecting waterways for a growing state, a canal system was developed in the early 19th century. The system required feeder lakes to supply the water necessary to maintain the four-foot canal water level. Because of their location, areas such as St. Marys, Indian Lake, Lake Loramie, Guilford, and Buckeye Lake were developed as part of the project.

The canal project was formally started by Gov. Jeremiah Morrow on July 4, 1825, in a special ceremony near Newark. In attendance was New York's DeWitt Clinton, the father of the Erie Canal. Ohio's canal system was becoming a reality. Construction of the dike blocking drainage into the South Fork of the Licking River began in 1826 and was completed in 1830, forming the Licking Summit Reservoir, which would eventually become Buckeye Lake. Before impoundment, the forests were not cleared, leaving large tracts of timber and brush emergent in the newly formed lake.

As the water level rose, several large mats of sphagnum moss broke loose from the bottom and became "floating islands." Other islands were created because the land was above the water level.

During the canal era, canal boats traveled along the original western end of the lake. This lake however, was not large enough to supply the necessary water for the canal, so it was enlarged. Later, in order to provide an even larger amount of water, another lake was developed north and west of the original one. A dike, known as Middle Wall, separated the old reservoir and new reservoir. This dike was used as a towpath for the canal. With the advent of railroads, the canal system became outdated. Many miles of canal fell into disuse and were abandoned or sold. In 1894, the General Assembly of Ohio set a policy whereby the feeder reservoirs were established as public parks. At that time, the name of Licking Summit Reservoir was changed to Buckeye Lake.

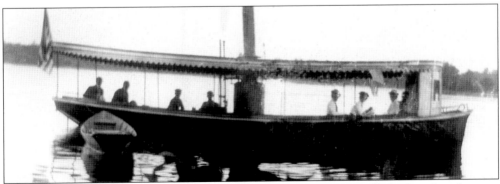

FIRST STEAM BOAT ON BUCKEYE LAKE, 1895. At the time, it was called a ferry boat because its main job was ferrying people who came to Buckeye Lake on the railroad to the various hotels on the lake.

BUCKEYE LAKE, OHIO

THE DIKE. In this early photograph, you can see how the dike was originally built with large stones, gravel, and dirt.

MINTHORN LOCK ON THE OHIO CANAL. The canal boats entered the lake area at the Minthorn Lock.

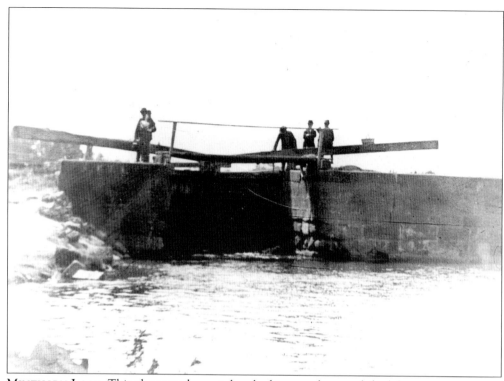

MINTHORN LOCK. This photograph was taken looking south toward the lake.

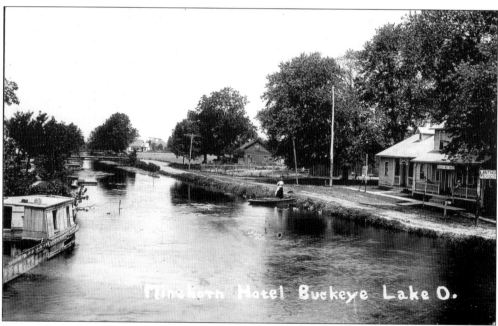

CANAL BOAT. This is a photograph of a typical packet canal boat with the Minthorn Hotel in the background. These boats were used to carry passengers in both ends. Men sat in one end, women and children in the other end, and freight was hauled in the center section.

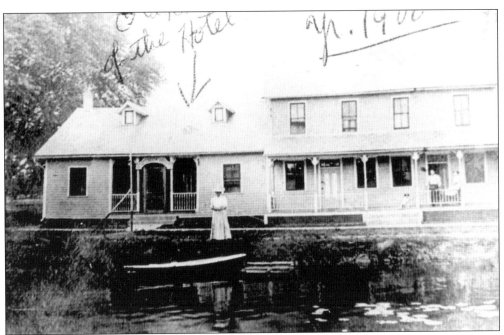

MINTHORN HOTEL. Thomas Minthorn was an early pioneer in the lake area when he built a log cabin at Lakeside. It was the center point of much activity as it became a packet station where horses were relayed so that boats might proceed along the canal. Outdoors there was a large kettle that held wild turkey, venison, dumplings, or green corn. Food and lodging cost $1.06 per week.

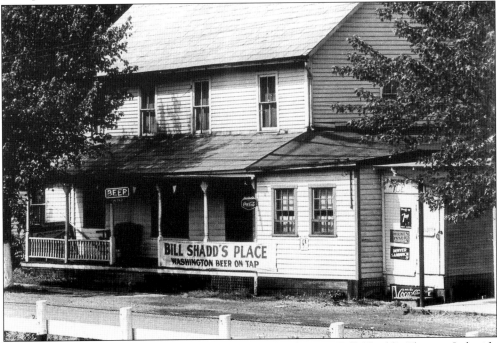

MINTHORN HOTEL. At the time of the photograph, this was Bill Shadd's Place at Lakeside (what is now Route 360).

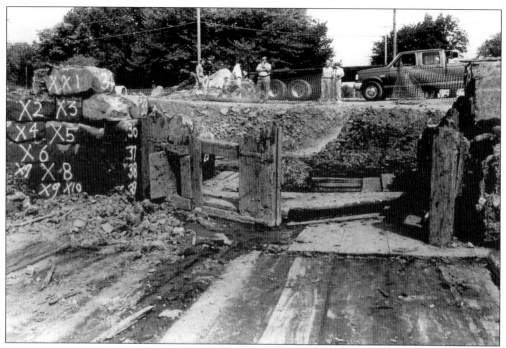

REMOVAL OF THE LOCK. Excavation and removal of Minthorn Lock by the Licking County Archaeology and Landmarks Society was done in 1991.

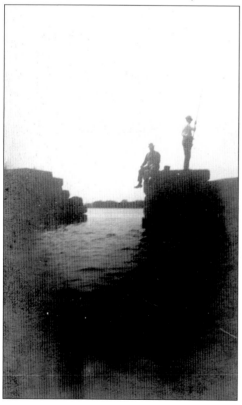

THE FLUME GATE. This is a very rare photograph (c. 1870) given to the author by Nina Harlow. Nina got her name by being the ninth child in the Harlow family. Her father was the game warden at Buckeye Lake. The photograph shows the area where the flume gate was located. This location was called middle bank and was in the center of the lake between Sellars Point and Millersport. The purpose of the gate was to allow water from the new reservoir to be pumped into the old reservoir so that the old reservoir would always be filled to capacity. The action of muskrats, turtles, beavers, and other aquatic life caused the dike to remain porous, and the water level in both the new and old reservoirs always remained the same. The author has the original copy of a special report by the Board of Public Works dated February 2, 1857, which states that the water in the lake was always insufficient to supply the needs of the canal. This wall was totally underwater by 1890.

Two

THE INTERURBAN

On September 17, 1901, Elias and Eliza Swick sold approximately 35 acres of what was known as the Swick Hotel property at Buckeye Lake to the Columbus, Buckeye Lake, and Newark Traction Company for $3,500.

On March 18, 1903, the Bounds family sold 65 acres of land to the Columbus, Buckeye Lake, and Newark Traction Company for $10,000. The two parcels were purchased for the purpose of building an amusement park that became Buckeye Lake Park.

The traction company, in order to get people to ride the cars, put a park at the end of the lines, and people poured onto the trains to go to the park for the day. The interurban line came to Buckeye Lake Park from Columbus, through Hebron, and out what is now Route 79. The trains originally deadheaded into the Dell Fisher Pier located near the Swick Hotel. Later the trains came in and around a loop and back out.

The interurban ran until the 1920s. The Hebron School Board gave the children of Buckeye Lake tickets to ride to Hebron School, and the author rode the interurban to school in first and second grades.

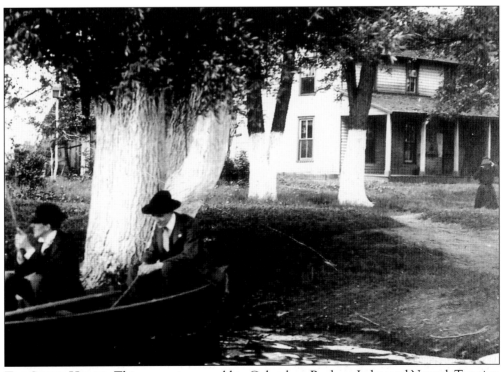

THE SWICK HOTEL. This property was sold to Columbus, Buckeye Lake, and Newark Traction Company in 1901.

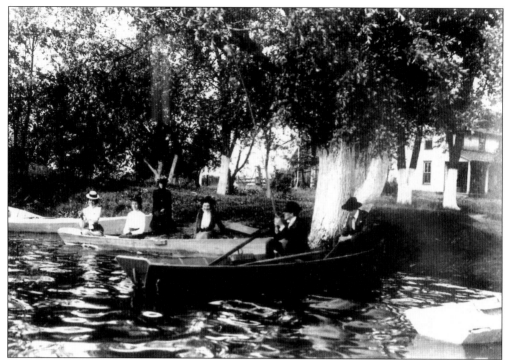

THE SWICK HOTEL IN BACKGROUND. This is the property the Swick family sold to the Columbus, Buckeye Lake, and Newark Traction Company. This site is where the traction company would eventually build a park.

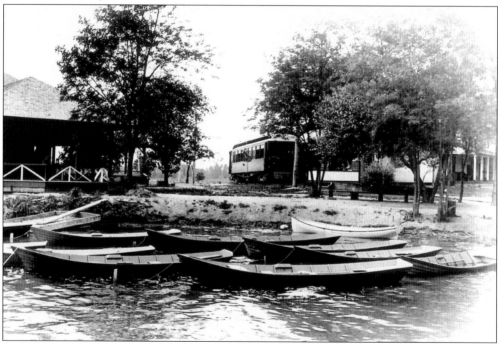

AN INTERURBAN CAR. The interurban car is seen in the photograph at the point of the Swick Hotel with the lake in the foreground. The first dance hall is the building on the left, *c.* 1904.

BUCKEYE - LAKE PARK.

THE LOOP. This photograph shows an interurban car after the loop had been constructed. This allowed the trains to come in, around, and out.

INTERURBAN ADVERTISEMENT. This advertisement announces "Excursions! To Buckeye Lake."

The Columbus, Buckeye Lake and Newark Traction Co.
TIME CARD.

East Bound.					West Bound.				
STATIONS	A. M.	Fare	Round Trip	Miles from Columbus	STATIONS	A. M.	Fare	Round Trip	Miles from Newark
Lv. Columbus	6 00	Thereafter every hour until 10 P.M.			Lv. Newark	6 00	Thereafter every hour until 10 P.M.		
Capital University	6 25	5c	10c	4.2	° Hebron	6 30	15c	25c	9.3
Doneys	6 30	10c	20c	6.9	Kirkersville	6 45	25c	40c	15.
Reynoldsburg	6 40	15c	25c	11.1	Etna	7 00	35c	55c	19.6
Wagram	6 50	20c	35c	14.9	Wagram	7 10	40c	65c	22.
Etna	7 00	25c	45c	17.3	Reynoldsburg	7 20	45c	75c	25.8
Kirkersville	7 15	35c	60c	21.9	Doneys	7 30	50c	85c	30.
° Hebron	7 30	45c	75c	27.6	Capital University	7 35	55c	95c	32.7
Ar. Newark	7 50	60c	1 00	36.9	Ar. Columbus	7 50	60c	1 00	36.9

(Running Time between Columbus and Newark, 1:50)

° Connections at Hebron for Buckeye Lake with every car from Columbus and Newark.
During theatre season cars will leave both Columbus and Newark at 11:00 P. M.

Cars Run on Central Standard Time.
All Cars Have Smoking Compartments.
Special Rates to Picnic Parties.

Visit the Great Summer Resort
❀ ❀ **BUCKEYE LAKE.** ❀ ❀

TIME CARD. This is a photograph of a Columbus, Buckeye Lake, and Newark Traction Company time card.

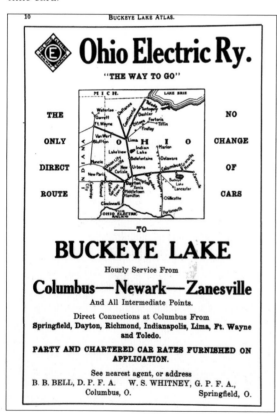

INTERURBAN ADVERTISEMENT. This advertisement is from the *Buckeye Lake Atlas* and advertises "the only direct route" to Buckeye Lake.

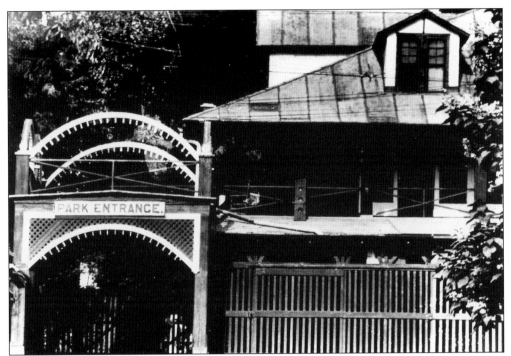

PARK ENTRANCE AT HARRIS HOTEL. The area to the right was called the Bull Pen, and the sliding gate was to hold the people back until passengers from the previous train had cleared the area.

INTERURBAN CAR. This photograph shows a typical interurban car that the author rode to Hebron School in 1923 and 1924.

DELL FISHER PIER. The interurban came to this area before the loop was built. Engines were located on each end. They deadheaded here at the Dell Fisher Pier and backed out leaving in the opposite direction.

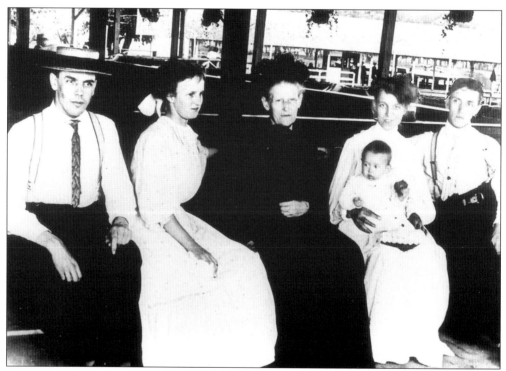

INTERURBAN WAITING ROOM. This photograph shows people as they waited for the interurban car. Dell Fisher Pier is located over the water in the background.

20

THE NATIONAL ROAD. This is the National Road as it appeared before the Columbus, Buckeye Lake, and Newark Traction Company line was built. There was very little automobile transportation at this time due to the unpaved roads, which made it very difficult to travel to Buckeye Lake. This photograph illustrates how important the interurban was to the park.

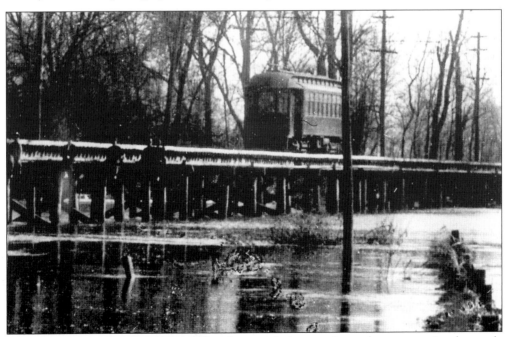

TRESTLE OVER THE LICKING RIVER. This photograph shows an interurban car crossing the trestle that carried it over and above the South Fork of the Licking River. Please note the flooding in this photograph. This photograph was taken prior to 1924, at which time neither the new spillway nor Interstate 70 had been built.

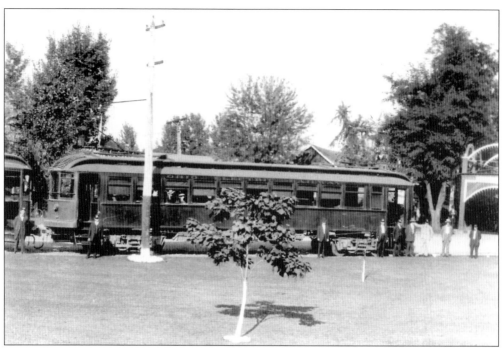

INTERURBAN CAR. A typical passenger car on the Columbus, Buckeye Lake, and Newark railway is shown here.

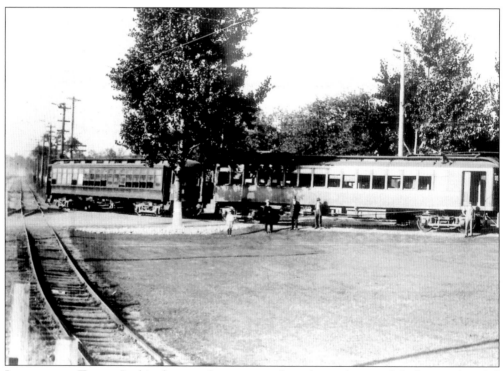

INTERURBAN TRACK. In this photograph you can see how the track entered the loop and circled around on its way back to Hebron.

Three

A Trip around the Lake, Pre-1930

This chapter starts at Sellars Point and proceeds around the lake to show how each and every area appeared. The start will be the north bank, and travel will proceed to the yacht club area, the Hotel Glass, and Lake Breeze area. The images will travel on to the amusement park, the Bounds Addition, Cranberry Marsh, Blue Goose, Harbor Hills, the east end of the lake, and Thornport and follow up with photographs of the south side of the lake all the way to Millersport.

REMAINS OF ORIGINAL WALL. In 1956, the lake was lowered during the building of the Buckeye Lake sewer system. In this photograph, the remains of the original wall that went across the lake can be seen. The west bank went from Sellars Point to Onion Island on its way through Millersport to what was called the deep cut area.

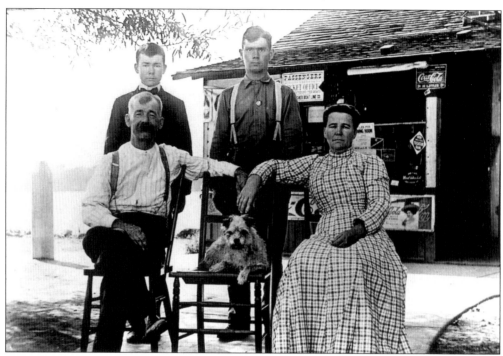

THE SELLARS HOTEL AND FAMILY. Mr. and Mrs. George Sellars and their two sons are seated in front of the Sellars Hotel at Sellars Point.

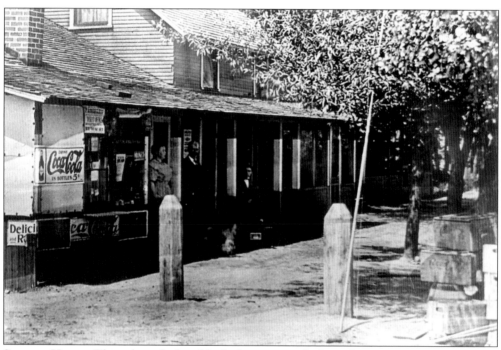

SELLARS HOTEL. This is how the hotel looked many years before it became Smitty's Restaurant. The hotel had 16 rooms that rented for $1 per day and $7 per week. Meals were 35¢ each.

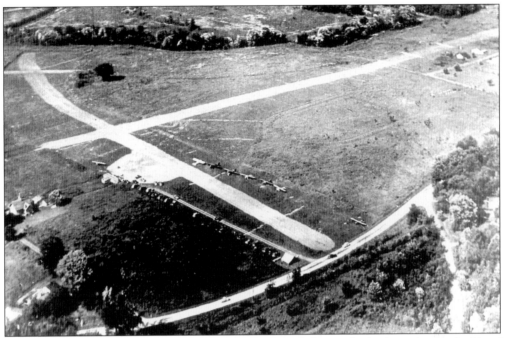

BUCKEYE LAKE AIRPORT. The first airport at Buckeye Lake was built along the north side of Route 360 on the property known as Hollywood Farms.

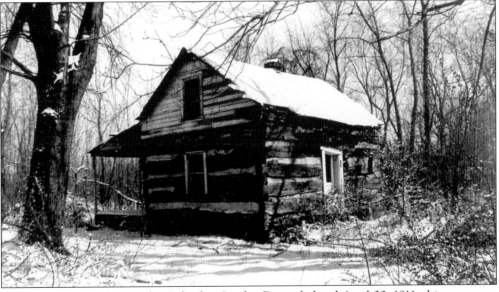

LOG CABIN. According to the *Columbus Sunday Dispatch* dated April 30, 1911, this two-story, two-room cabin was said to have housed the first mayor of Franklinton, the hamlet that was later made the capital of Ohio under the name of Columbus. It was torn down by owner Sheriff Al Sartain and reerected at Buckeye Lake as a summer cottage. According to newspaper stories from the early 20th century, there were two log cabins that were not built at Buckeye Lake but moved from someplace else. This is an interesting question; is this one of the cabins that was moved to Buckeye Lake along Route 360? Orie England moved into this log cabin November 12, 1919, on what was part of his 90-acre farm.

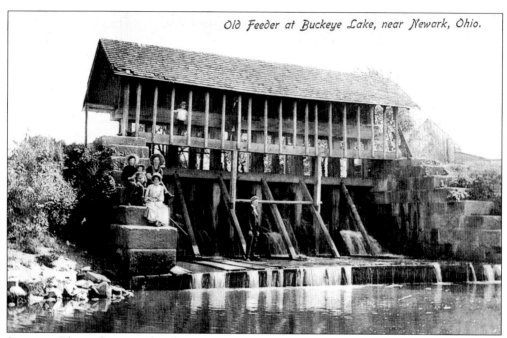

Old Feeder at Buckeye Lake, near Newark, Ohio.

SPILLWAY. This is the original spillway on the Rosebraugh property located along the North Bank.

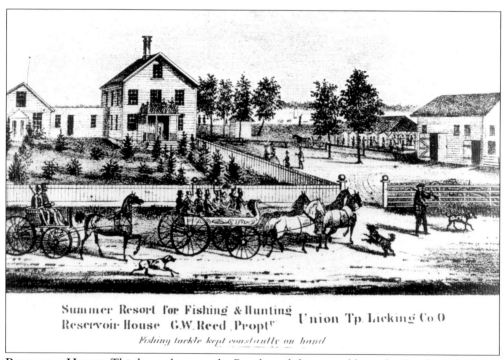

Summer Resort for Fishing & Hunting
Reservoir House G.W. Reed, Propt. Union Tp. Licking Co. O

Fishing tackle kept constantly on hand

RESERVOIR HOUSE. This house became the Rosebraugh home and later the Rosebraugh Hotel.

CUTTING ICE ON THE LAKE.
This photograph shows B. F.
(Ben) Kain cutting ice. Ice was
stored in the Rosebraugh Ice
House along North Bank.

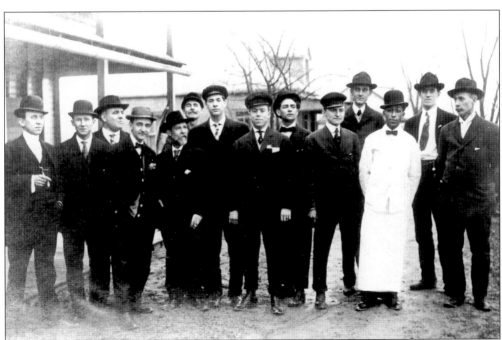

BUCKEYE LAKE CAMERA AND FISHING CLUB. This photograph was taken in 1917 along the
North Bank near the Buckeye Lake Yacht Club.

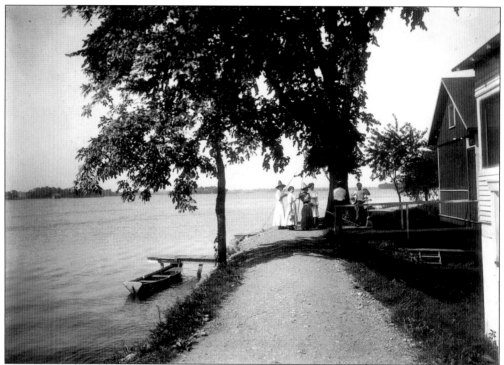

SCENE ALONG THE NORTH BANK. This photograph was taken just east of the Buckeye Lake Yacht Club.

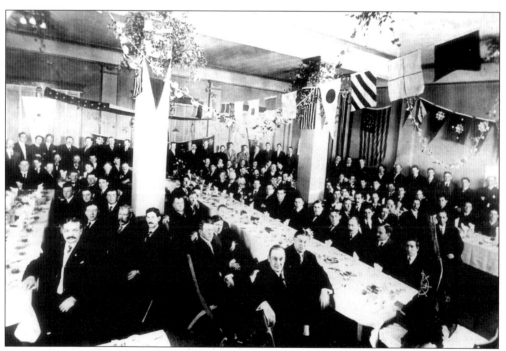

FOUNDING OF THE BUCKEYE LAKE YACHT CLUB. The founding event took place at Leachman's Restaurant in Columbus on the evening of April 24, 1906.

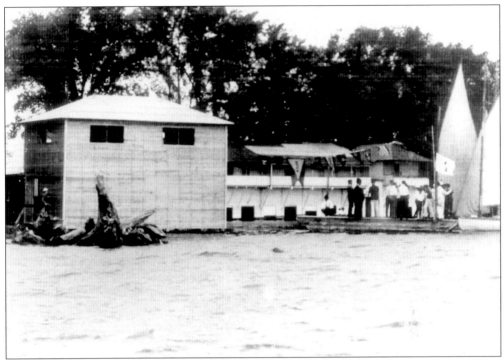

BUCKEYE LAKE YACHT CLUB. This photograph is of the first yacht club at Buckeye Lake, 1906.

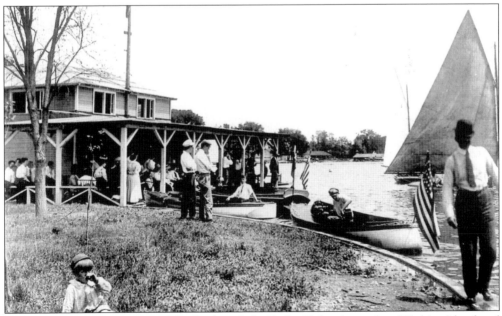

BUCKEYE LAKE YACHT CLUB. The Buckeye Lake Yacht Club is located on Watkins Island and is the only island yacht club in America.

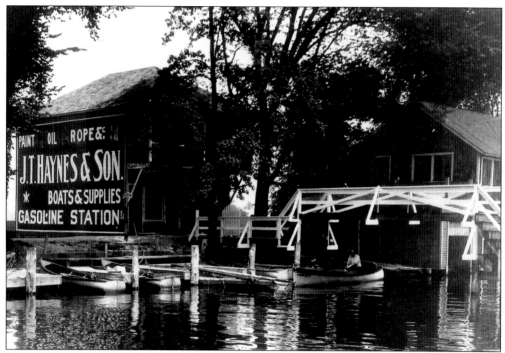

BOAT SUPPLIES. J. T. Haynes and Son sold boat supplies in back of the yacht club along North Bank. Note the overhead bridge leading to the yacht club so boats could pass under the walkway.

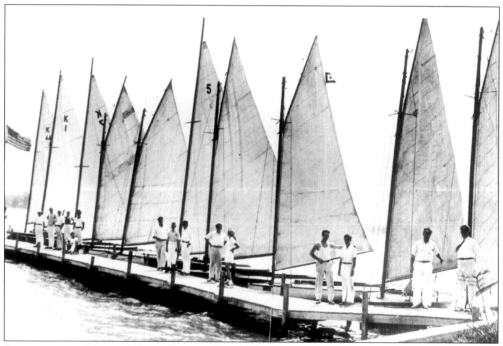

SAILBOATS AT BUCKEYE LAKE YACHT CLUB. The year 2006 will be the 100th anniversary of the Buckeye Lake Yacht Club.

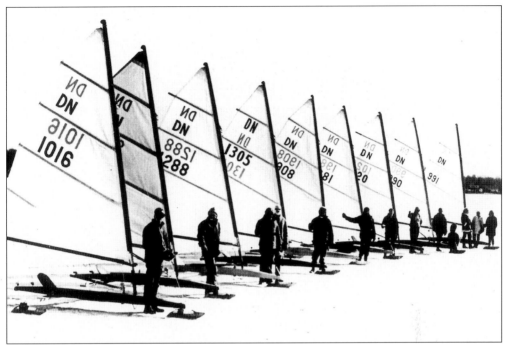

ICEBOATS AT BUCKEYE LAKE YACHT CLUB. Iceboating was very popular in the 1920s and 1930s, at which time the lake would be frozen solid for several months out of the year.

NORTH BANK. This photograph was taken in back of the yacht club around 1904.

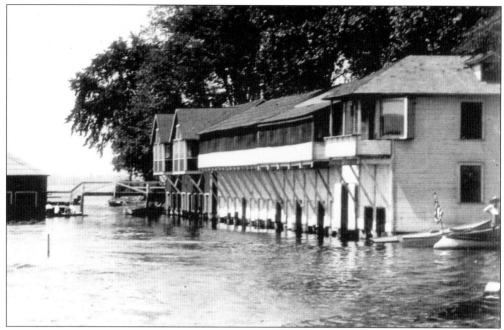

BUILDINGS ALONG NORTH BANK. These apartment buildings were built over the water and were partially destroyed in the 1928 tornado.

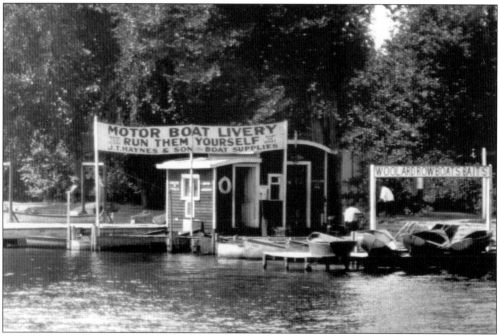

MOTOR BOAT LIVERY. This boat livery was operated by J. T. Haynes and Son and was located next to Sayre Brothers Marina. Sayre Brothers was the oldest Chris Craft dealership in the United States. It was established in 1904, and it is still in operation today. The boat dock to the right was owned by the Woolard family, who also owned the Woolard Hotel, which became known as the Tavern in recent years.

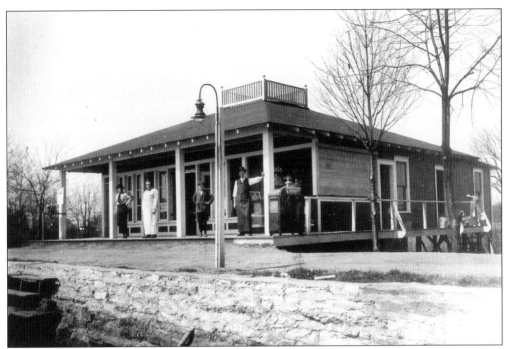

SAYRE BROTHERS RESTAURANT. Sayre Brothers also owned this restaurant, which was located on North Bank just west of the yacht club.

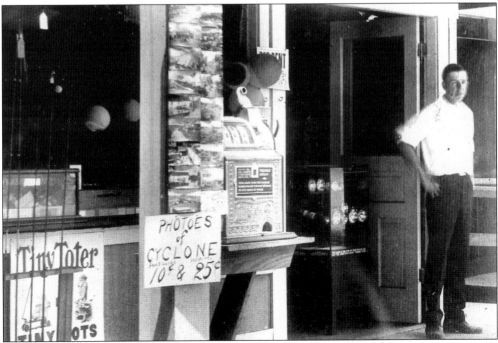

JIM HAYNES. This photograph shows Jim Haynes in front of the Hayneses' store, along the North Bank, which sold boat supplies. Note the slot machine in the center of the picture. Slot machines were common along the North Bank in some of the concession buildings in the 1920s and 1930s.

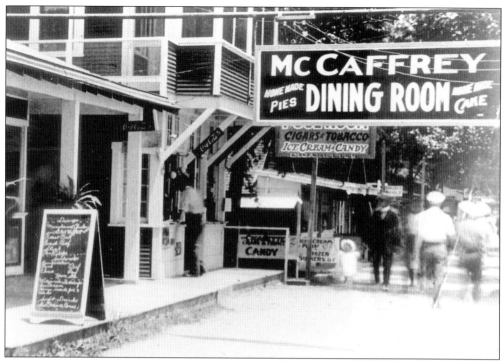

McCafferey Dinning Room along the North Bank. The dinning room featured homemade pies and cakes.

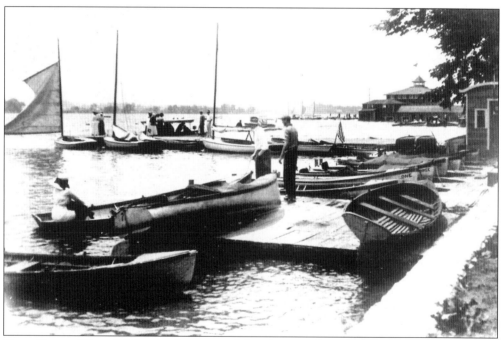

Crab Baker. The tall fellow in the center of this photograph is "Crab" Baker, owner of Baker's Johnson Outboard Motor Sales. He had the oldest franchise for Johnson Outboard Motors in the United States.

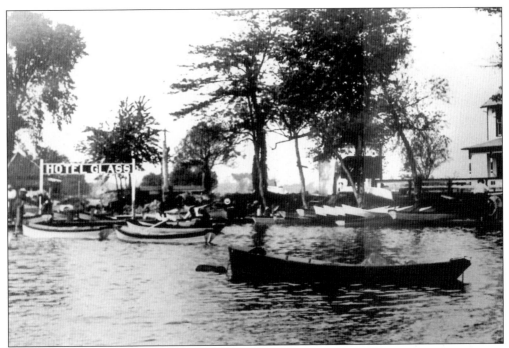

HOTEL GLASS. Building of the Hotel Glass was started March 29, 1914.

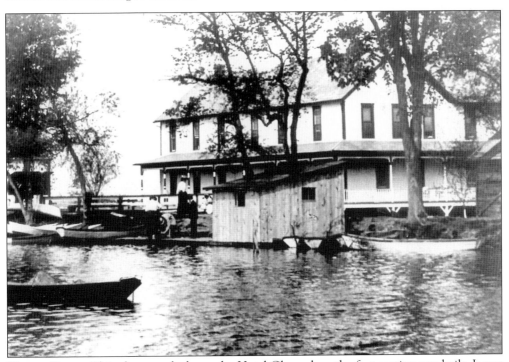

HOTEL GLASS. This photograph shows the Hotel Glass when the first section was built. It was later doubled in size, the two sections were joined together, and a dinning room was included. This hotel had 100 rooms, running water, and electric lights. Rates were $1.25 and up. A large veranda, running the full length of the hotel, overlooked the lake.

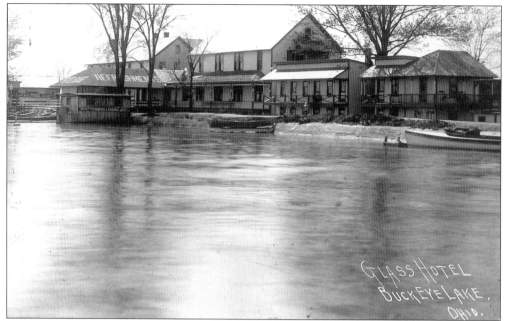

HOTEL GLASS. This photograph shows the Hotel Glass when it was completed. The building alongside the hotel was called Ladies Rest, which was a hotel for women only.

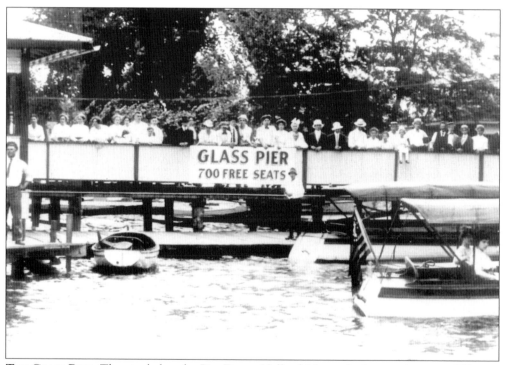

THE GLASS PIER. The pier led to the Pier Dance Hall, which was built over the water. When it was built, state law required that the dance hall not be attached to the land. It had to be built offshore, so the pier was built for people to walk across to the dance hall.

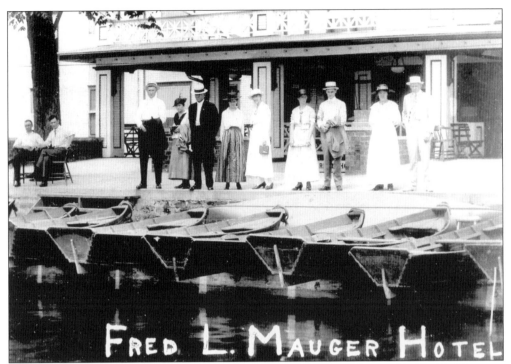

MAUGER HOTEL. The Hotel Glass was sold and became Mauger Hotel, owned by Fred L. Mauger.

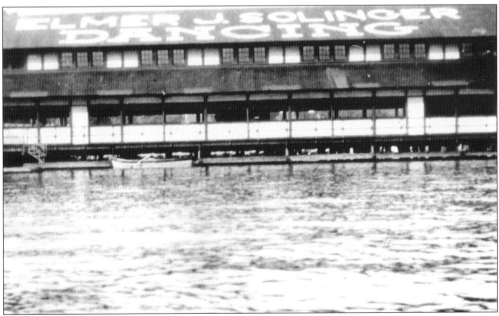

MAUGER HOTEL. This is a photograph of the Mauger Hotel showing how it was built over the water. The name on the roof is that of the manager Elmer J. Solinger. His ambition was to provide lovers of dancing the best the county had to offer in dance music and brought to his pavilion dance orchestras of national recognition. He was also a Newark barber who gave the author his first haircut.

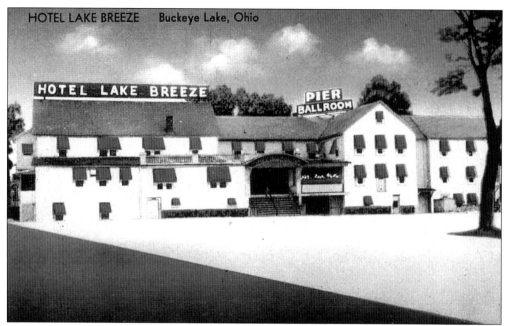

LAKE BREEZE PIER. Later on, the same dance hall became the Lake Breeze Pier.

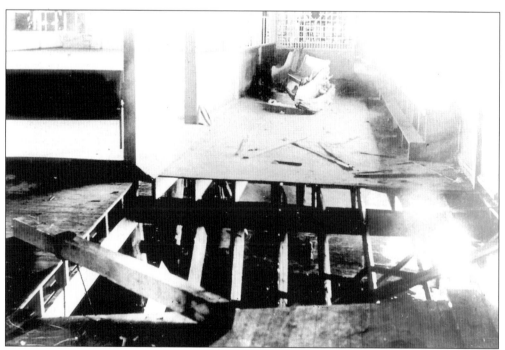

LAKE BREEZE PIER. This photograph shows a small section of the dance floor, which collapsed during the Colored Picnic, 1924, which was held the first Thursday in August with the Zanesville Elk's Club being the host sponsor every year.

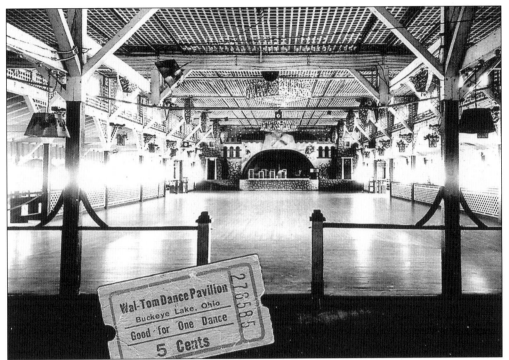

WAL-TOM DANCE PAVILION. This is the dance floor when it was known as the Wal-Tom Dance Pavilion. It got its name from a combination of the names of the two people who leased the dance hall for a year. There names were Tom Edwards, owner of the Coca-Cola Bottling Company in Newark, and Walt Dement, owner of the Chatter Box restaurant located on the north side of the square in Newark. Note the dance ticket—5¢ per dance.

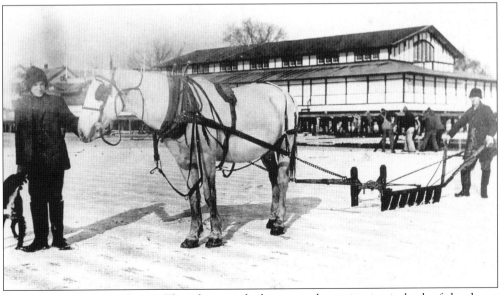

ICE CUTTING ON THE LAKE. This photograph shows people cutting ice in back of the dance hall. A marker, which was horse drawn, cut a mark on the ice 32 inches across where the ice would be cut for future storage in the icehouse.

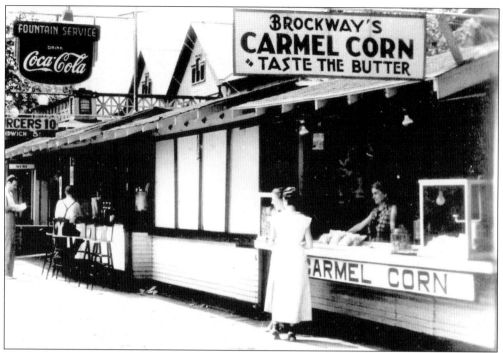

PARK CONCESSION. This photograph shows Brockway's Caramel Corn concession in front of the Lake Breeze Hotel around the 1920s.

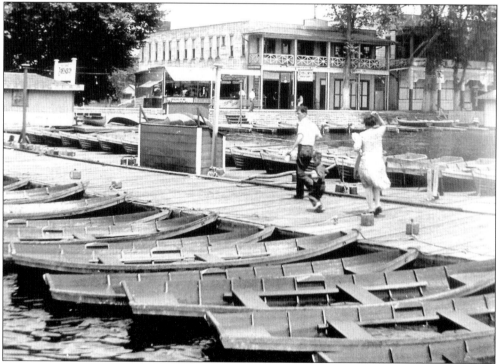

SCENE ALONG THE WATERFRONT. Elliot's Row Boats are for rent in the foreground, and in the background is the Commercial Hotel.

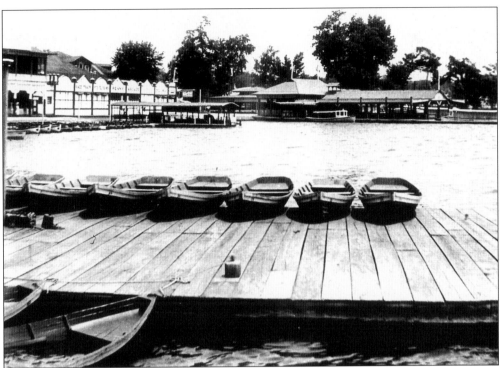

CONCESSIONS ALONG THE WATERFRONT. The Dell Fisher Pier is in the background.

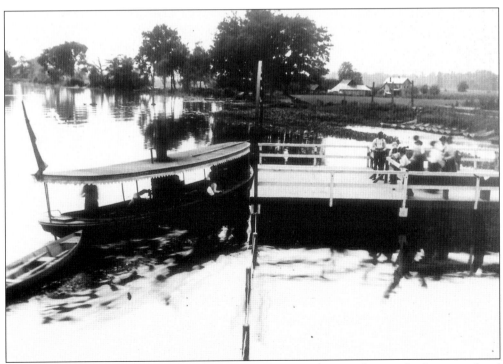

ORIGINAL SITE OF DELL FISHER PIER, 1900. Here you see the steamboat in the foreground and in the background, the Woolard Hotel, which is now the Tavern.

BUCKEYE LAKE PARK, 1904. The Crane Lake is visible in the background.

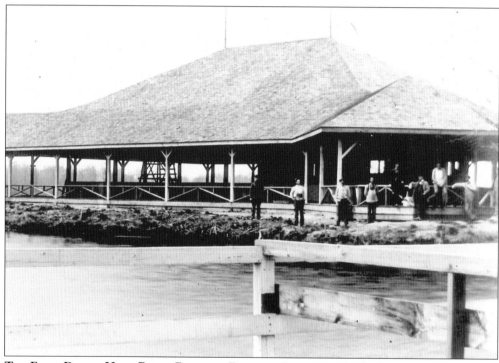

THE FIRST DANCE HALL BEING BUILT AT BUCKEYE LAKE, 1904. The dance hall was built by the Columbus, Buckeye Lake, and Newark Traction Company, who owned the property. Note how near the shoreline was to the dance hall.

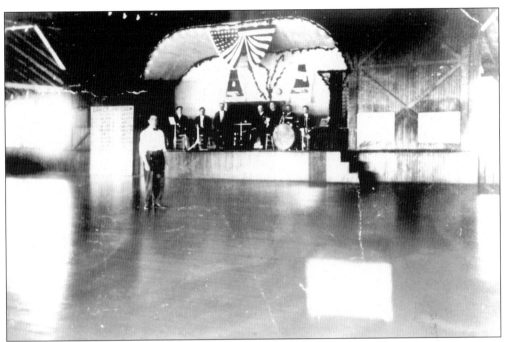

FIRST DANCE HALL WHEN COMPLETED. This building later became a theater for showing silent movies, and in the 1930s, it became a bowling alley.

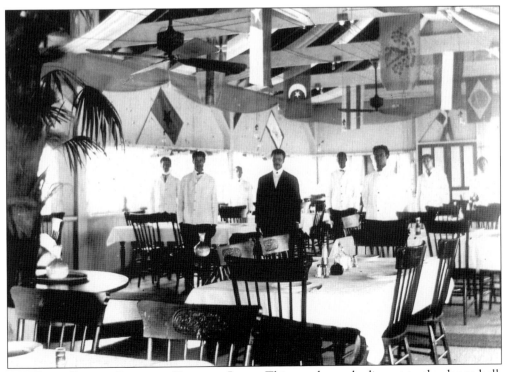

THE FIRST DINING ROOM AT BUCKEYE LAKE. This was located adjacent to the dance hall. Note the male waiters and linen tablecloths.

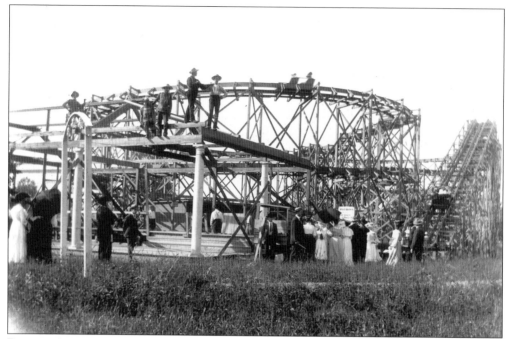

ROLLER COASTER. The first roller coaster–type ride was constructed by George Ehert Sr. in 1904.

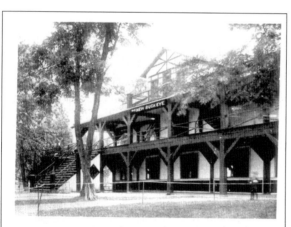

The New Buckeye Hotel
FOR GENTLEMEN ONLY
FORTY ROOMS

Especially designed for gentlemen who enjoy bachelor apartments.

· Remodeled and refurnished. Running water in every room. Electric lights.

Rates $1.00 a day.

THE NEW BUCKEYE HOTEL. Advertised for "Gentlemen Only," the new Buckeye Hotel featured running water in every room and electric lights for only $1.00 per day.

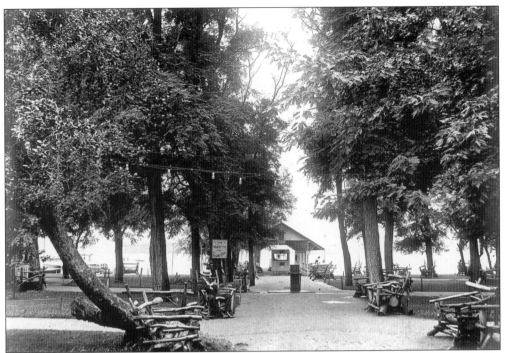

DELL FISHER PIER, 1929. Note the sign on the tree points out the path to the ride called Canals of Venice.

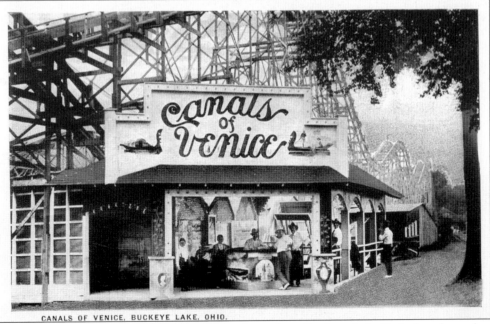

CANALS OF VENICE, BUCKEYE LAKE, OHIO.

CANALS OF VENICE BOAT RIDE. This is the first ride at Buckeye Lake Park that the author remembers. He was nearly four years old when he rode this very scary ride. The little boat floated past screeching wild beasts, spiders, and bats. The ride was completely destroyed when the roller coaster came down on it in the 1922 tornado.

OLD-TIMER NEAR DELL FISHER PIER. This photograph was taken just west of the Dell Fisher Pier, and the old-timer in the front is Dell Fisher's father. The Hotel Glass is in the far background.

MISS SCHNEIDER, 1904. This young lady was from Columbus. Buckeye Lake is in the background. Note the dress of the day.

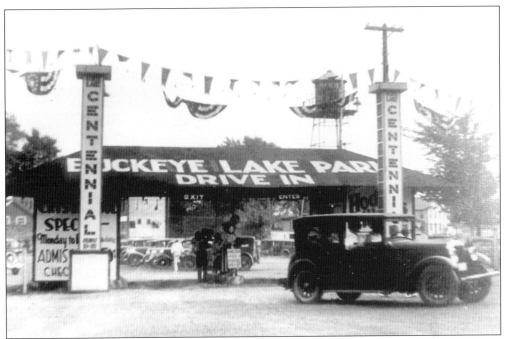

BUCKEYE LAKE PARK ENTRANCE. This photograph was taken during the Centennial Celebration.

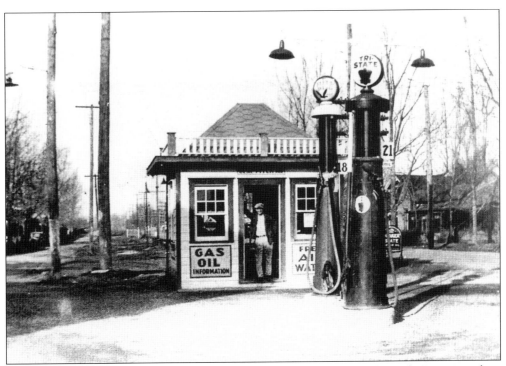

FILLING STATION. This filling station sat across from the entrance to the park. Facing north, it was between the roads with the Neal Addition being on the left and the Myers and Holtsberry Additions on the right.

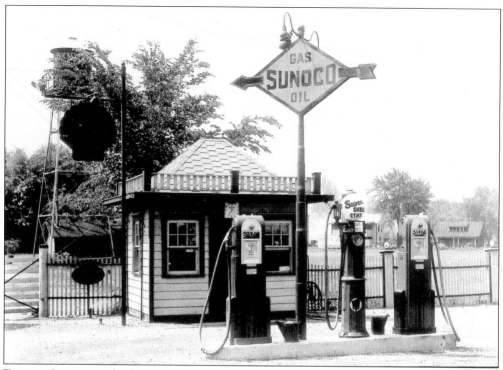

FILLING STATION. The filling station was moved across the road alongside the park entrance. The Park Company water tower is shown in the background.

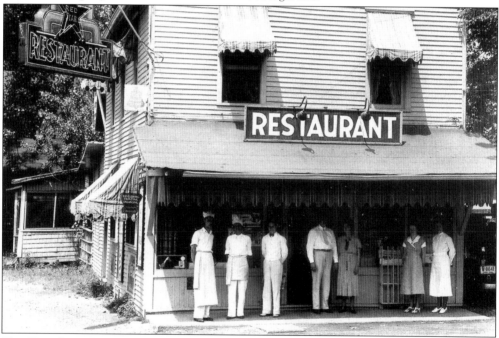

THE RED STAR RESTAURANT. This restaurant was located at the entrance to the park and owned by Mae Cohee. The Red Star Restaurant served chicken, frog, steak, fish, and special dinners. They advertised "home like surroundings," and their motto was "courteous service."

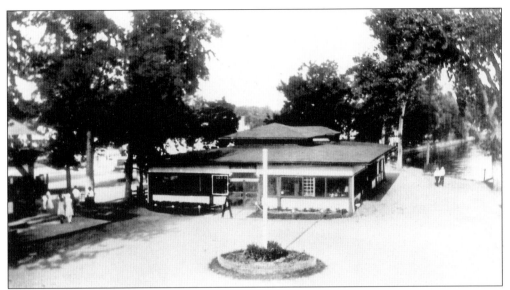

THE LILAC ROOM. The author's father was the manager of this restaurant plus two other eat-and-drink concessions, which were two-story buildings. The upper floors were open on all four sides, and bands played Sunday afternoon concerts. It is interesting to note that at that time there was no electric refrigeration. On each side of the concession there were two deep tanks, which were filled with ice to keep bottled soft drinks cold. No alcoholic beverages were sold at the park at this time, around 1917.

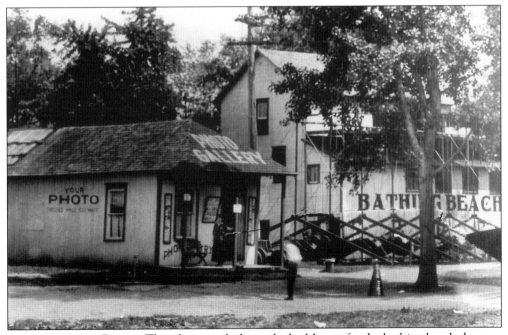

BATHHOUSE AND BEACH. This photograph shows the bathhouse for the bathing beach that was on Crane Lake. George Lore's photograph gallery was on the left. George Lore was the official park photographer. He photographed all company picnics with a panorama camera, which took photographs of huge crowds from which prints were made 36 inches long and 9 inches high.

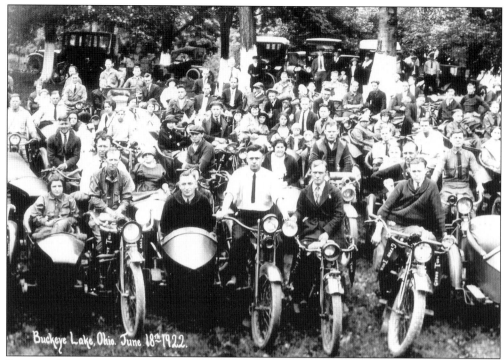

BUCKEYE LAKE PARK. The park was a popular spot for companies to bring their employees or for groups to hold their picnics. This photograph is of the Motorcycle Rider's picnic on June 18, 1922.

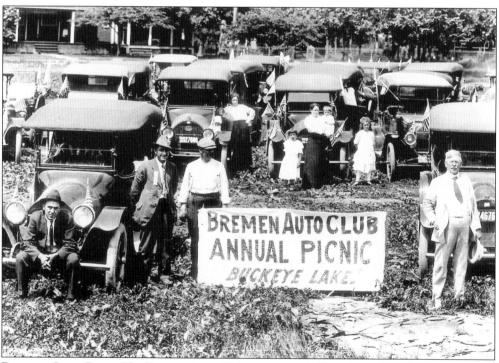

BUCKEYE LAKE PARK. The Bremen Auto Club picnic was held at the park each year.

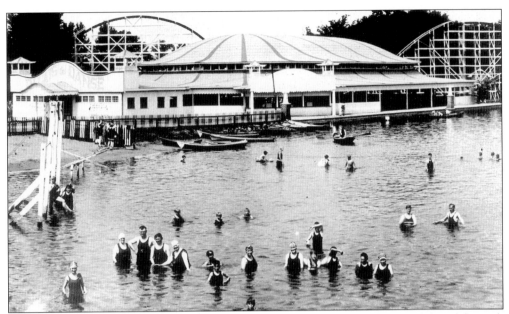

PALAIS DE DANSE. This building was built in 1922 and was one of the most popular of the park attractions. The immense mirrorlike floor of this pavilion would accommodate several thousand couples. A promenade surrounding the dance floor had ample seats for 1,000 spectators who enjoyed watching the dancing or listening to the wonderful music. When the Crystal Ballroom was built, this building became the skating rink. Note how close it was to the bathing beach on Crane Lake as well as the wool bathing suits of the day.

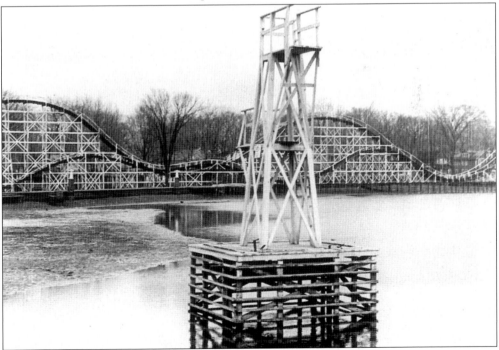

DIVING PLATFORM ON CRANE LAKE, 1920s. Notice the roller coaster in the background of this image of the diving platform on Crane Lake.

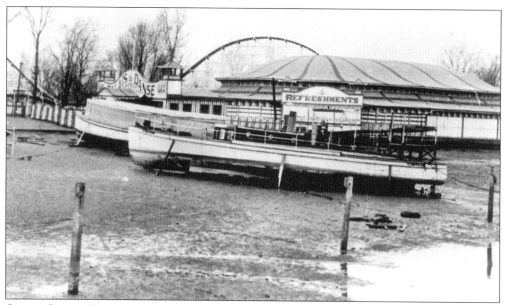

CRANE LAKE. Crane Lake was also an artificial lake. It was built for a special purpose. The passenger boats were stored in the little lake, which could be drained and the boats put on supports to be worked on, painted, caulked, and repaired during the winter months. After the boats were floated into the lake, a temporary wall made of wood was filled with sand and gravel. There was a drain in the center of the lake that allowed water to flow into the outlet to the spillway, which went across to the Neal Addition.

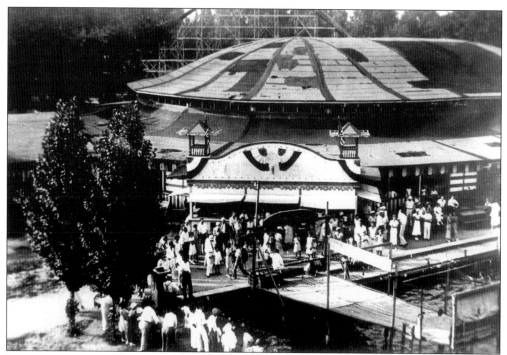

BOZO BALL GAME. This photograph shows the Bozo ball game when it was located in Crane Lake. The skating rink is in the background.

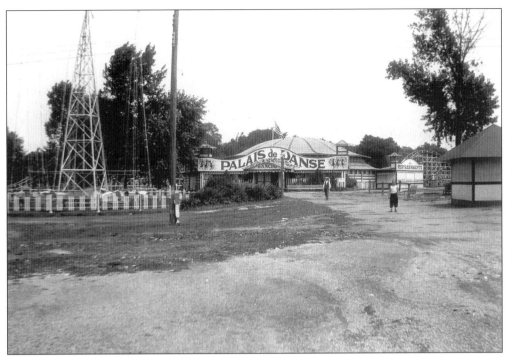

PALAIS DE DANSE. This is an early photograph of Palais de Danse with the airplane swing in the foreground.

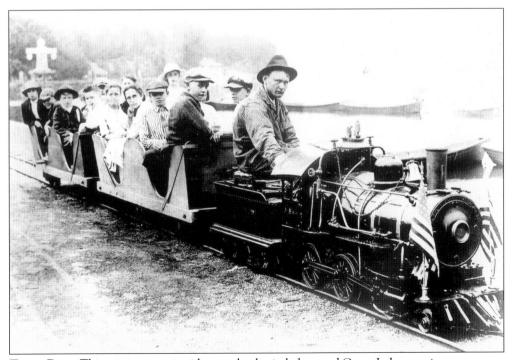

TRAIN RIDE. This miniature train ride completely circled around Crane Lake carrying passengers. Note the size of the small-scale railroad tracks.

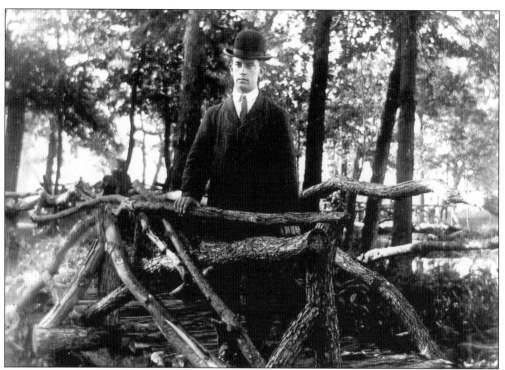

PICNIC POINT. At one time, Picnic Point was an island accessed by means of a rustic bridge.

PICNIC POINT, EARLY 1900s. The boat in the background is a stump puller that was used to pull stumps out of the lake.

COMMUNITY CHURCH ON PICNIC POINT. The church was also called Miller Memorial.

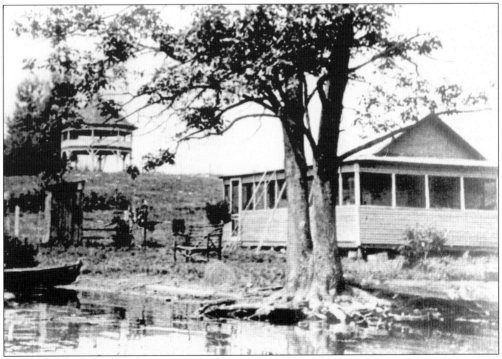

BEAUMONT AREA. The bandstand in the background stood on property sold by the Bounds family to the Columbus, Buckeye Lake, and Newark Traction Company.

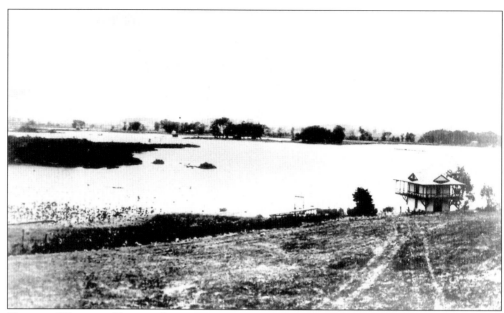

VIEW OF WESTERN END OF CRANBERRY MARSH, EARLY 1900s. When this photograph was taken, Cranberry Marsh covered approximately 56 acres. The land in the foreground became know as Beaumont Beach.

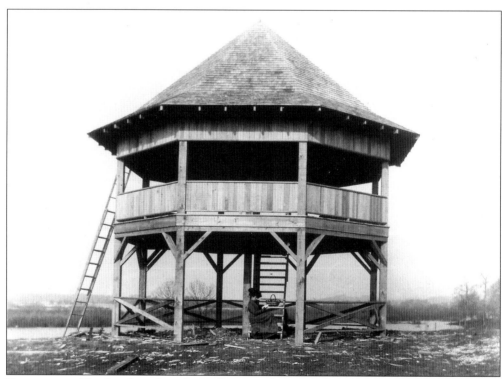

BANDSTAND. This bandstand was located on top of a high hill in the Bounds Addition and was used for band concerts. People would park their rigs, teams of horses, carriages, and automobiles around the bandstand to listen to the music.

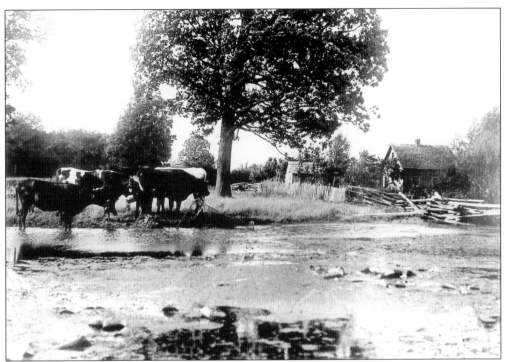

BLUE GOOSE, 1895. This area was part of the Bounds farm. Cows from the farm are pictured in the lake.

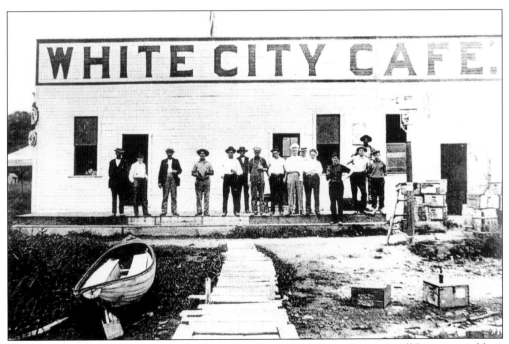

WHITE CITY CAFÉ. The café was located in the Blue Goose area. It was a well-known gambling site. There, money was taken to the Buckeye Lake Post Office and sent by mail to the bank for deposit, thus giving them insurance on their shipment.

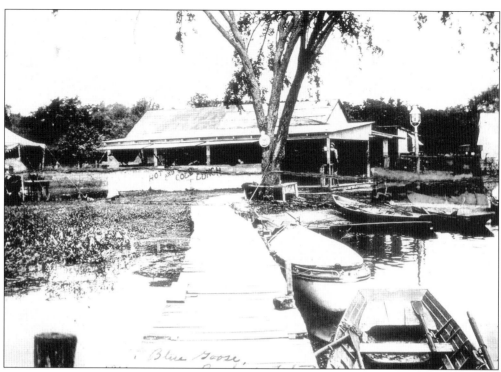

BLUE GOOSE RESTAURANT, 1910. This area is now called Cranberry Point.

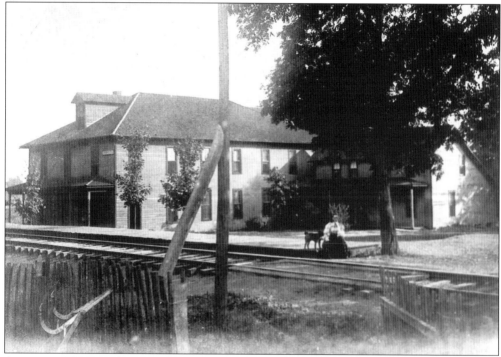

AVONDALE HOTEL. The Avondale Hotel was adjacent to the Baltimore and Ohio Railroad and was a stop along the eastern end of the lake.

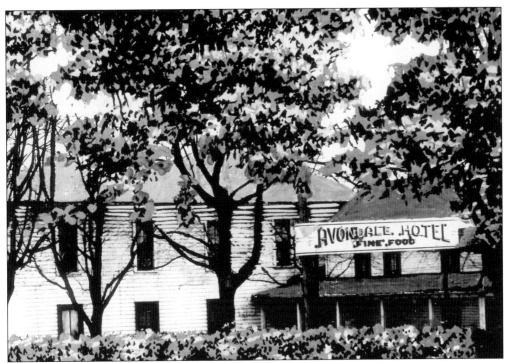

AVONDALE HOTEL. The hotel was located at the east end of the lake on the Baltimore and Ohio Railroad line. The hotel had 24 rooms that rented for $1.50 per day or $7 per week. Meals were available for 50¢.

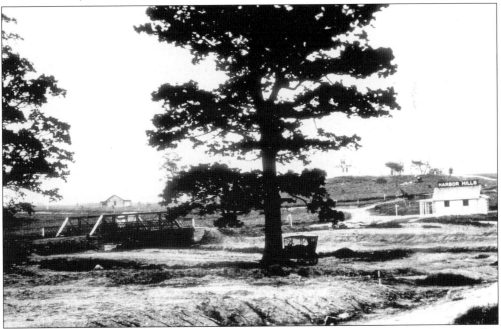

EARLY PHOTOGRAPH OF HARBOR HILLS. The building on the right was the real estate office for the company selling the original lots in Harbor Hills. The high hill in the background is the location of the Harbor Hills Club House and Golf Course.

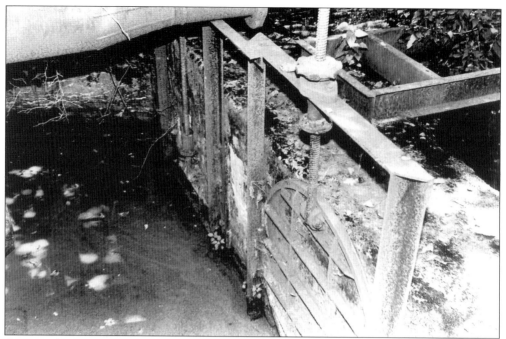

GATES. These gates were located at the eastern end of Buckeye Lake and were used up until 1924, along with the spillway on the North Bank, to lower the level of the lake during the winter. The water flowed under Route 13 on its way to Jonathon Creek, which carried the water to the Muskingum River near Zanesville.

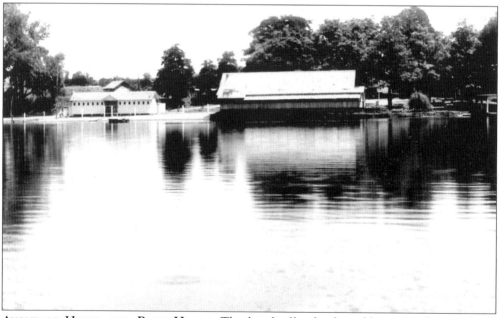

AVONDALE HOTEL AND BATH HOUSE. The hotel offered a homelike atmosphere with all foods home prepared. There was dancing at the pavilion on the water's edge. It had a modern bathhouse, which included showers. Avondale Park was recognized as a mecca for fishermen. There were picnic grounds and cozy cottages to be rented by the week.

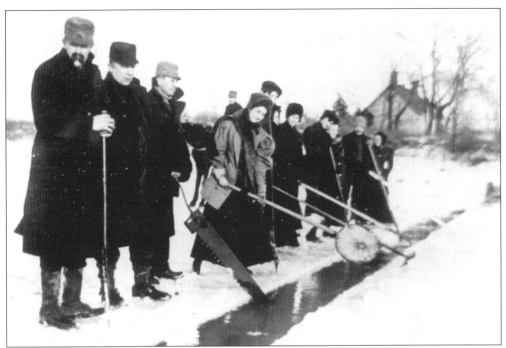

ICE CUTTING. Ice was cut along the south bank of Buckeye Lake during the winter of 1906. There were 10 to 12 icehouses surrounding the lake. The ice was cut into 32-inch blocks and stored in icehouses to be used in homes in the summer. This was before refrigeration.

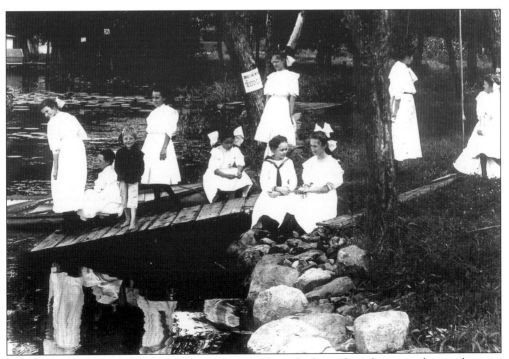

BUCKEYE LAKE. This photograph shows young girls, with their white dresses and pretty bows in their hair, enjoying a day at Buckeye Lake in 1904.

SOUTH SIDE OF LAKE. This photograph shows the area located near Fairfield Beach.

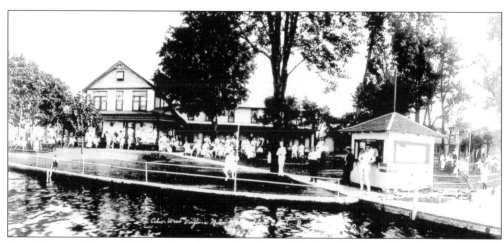

THE TOURIST HOTEL. This hotel was located on the south side of Buckeye Lake. It was sometimes called the Shell Beach Hotel.

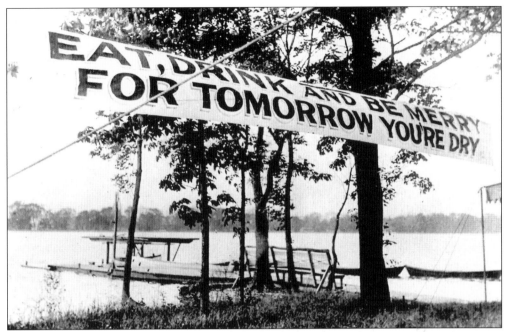

PARTY SIGN. This sign appeared when a party was held on the south side of the lake. It says "Eat, drink and be merry for tomorrow you're dry." This was the day before Prohibition. Many of the brewers from Columbus, Newark, and surrounding areas held a picnic at the lake for their families and employees.

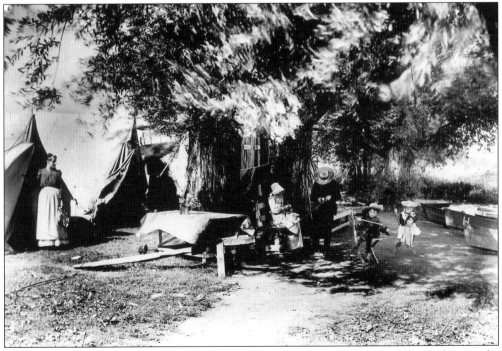

ALEXANDER'S LANDING, VERY EARLY 1900s. The letter *H* on the back of the rowboats is for Mary Hamilton, who owned the Hamilton Hotel on the south shore of Buckeye Lake.

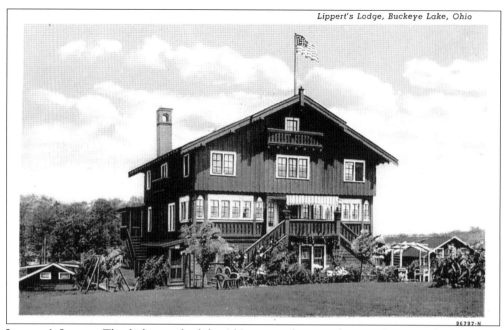

Lippert's Lodge, Buckeye Lake, Ohio

96797-N

LIPPERT'S LODGE. This lodge was built by Al Lippert, who was a liquor salesman. The lodge had a cathedral ceiling. It later became know as Holiday Lodge.

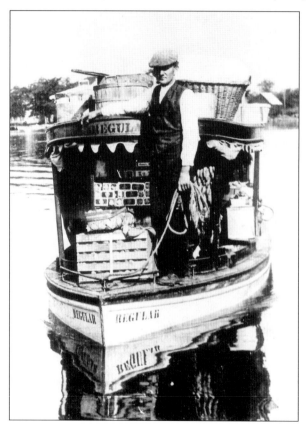

GROCERY BOAT. The *Regular* was a grocery boat operated by the Bowers brothers.

Four

BUCKEYE LAKE PARK, "THE PLAYGROUND OF OHIO"

Buckeye Lake Park was advertised as "the Playground of Ohio." There were free picnic grounds with tables for over 2,000 on elm-shaded Picnic Point. There were two very large and modern shelter houses made available at all times. No group was too small or too large to accommodate. There were plenty of free parking spaces in Picnic Point Parking Lot that adjoined the picnic grounds. The park had the largest fleet of speedboats in the Midwest, ready to serve at all times. There were excursion boats that left regularly on the half hour for a complete trip around the lake. The fabulous *J. B. Taylor* was a triple-deck stern wheeler that held 300 passengers. There was a bowling alley with eight air-conditioned lanes and two modern ballrooms playing the nation's top name bands. There was also swimming in beautiful Crystal Swimming Pool, miniature golf, and over 240 forms of entertainment.

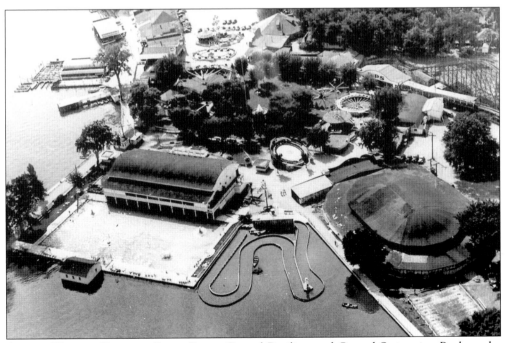

AERIAL VIEW OF BUCKEYE LAKE PARK. Crystal Pavilion and Crystal Swimming Pool can be seen in the foreground.

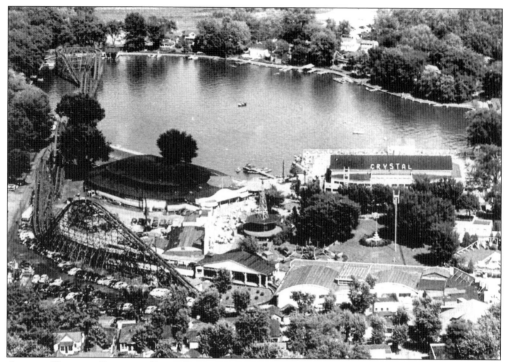

AERIAL VIEW OF BUCKEYE LAKE PARK. Crane Lake can be seen in the background.

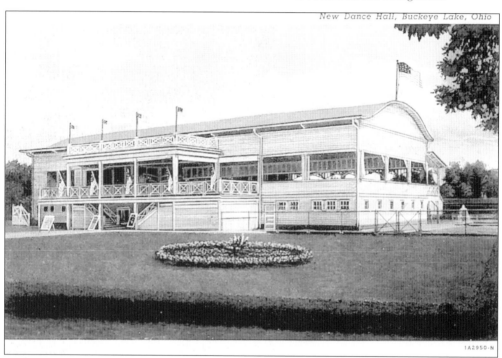

New Dance Hall, Buckeye Lake, Ohio

1A2950-N

CRYSTAL PAVILION, BUILT IN 1931. The Crystal Pavilion was built in front of the Crystal Swimming Pool. The bathhouse for the pool was on the lower level, and the dance hall was on the upper level.

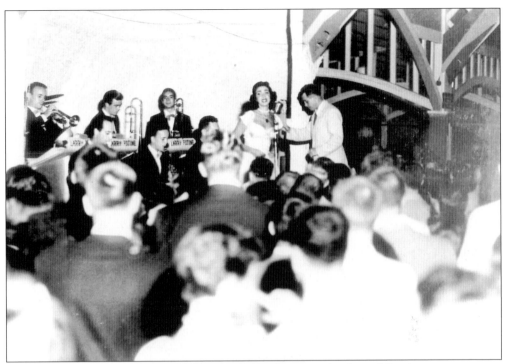

CRYSTAL PAVILION. Kitty Kallen was a popular performer at the Crystal Pavilion.

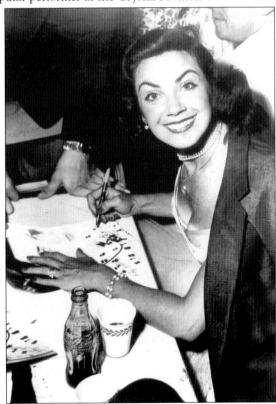

CRYSTAL PAVILION. Kitty Kallen signs autographs at the Crystal Pavilion.

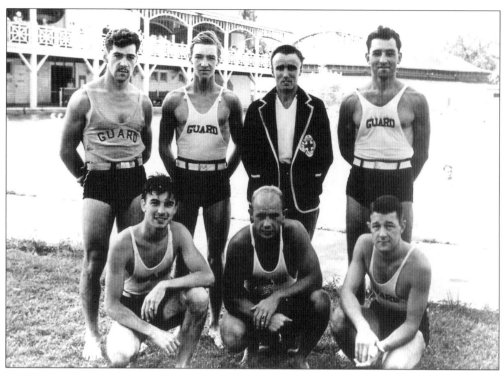

CRYSTAL SWIMMING POOL LIFEGUARDS. Bud Myer is pictured second from left in the back row, and Weldon Yontz in seen in the center of the front row.

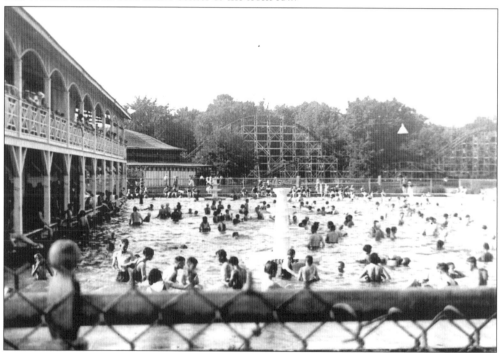

CRYSTAL SWIMMING POOL. This photograph shows swimmers enjoying the beautiful Crystal Swimming Pool during the summer months.

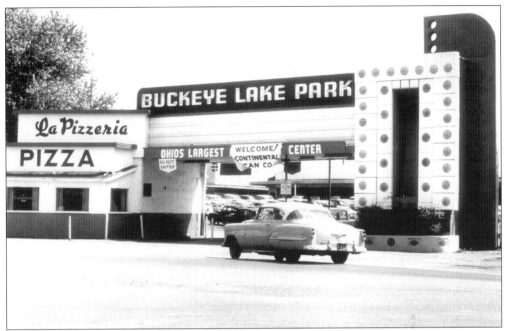

ENTRANCE TO BUCKEYE LAKE PARK, 1950s. The La Pizzeria was the first pizza restaurant at Buckeye Lake. It was owned by Robert and Lona McKay.

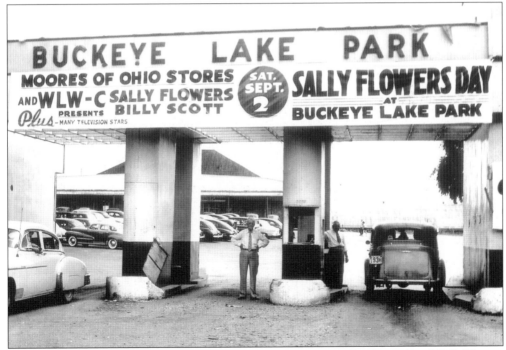

ENTRANCE TO BUCKEYE LAKE PARK. This banner celebrates "Sally Flowers Day." Billy Hoover is standing in the center of the entrance to park.

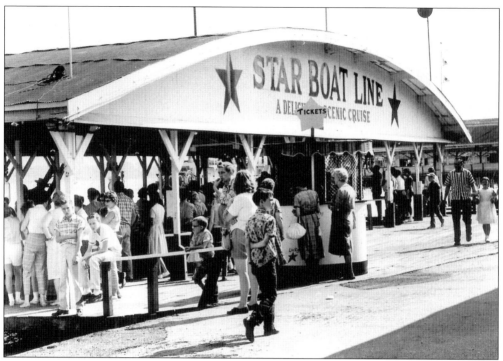

STAR BOAT LINE. The boat line had seven boats all named after stars, such as Morning, Evening, Silver, Eastern, Western, Northern, and Southern.

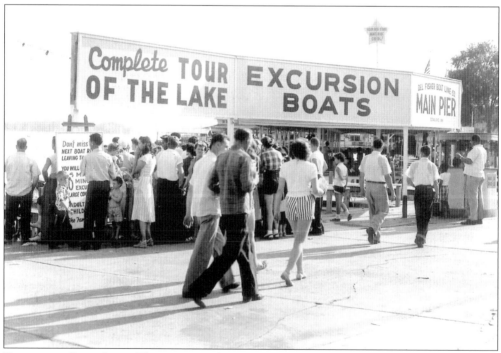

EXCURSION BOAT LINE. The excursion boats carried passengers from the Dell Fisher Pier to Summerland Beach and returned.

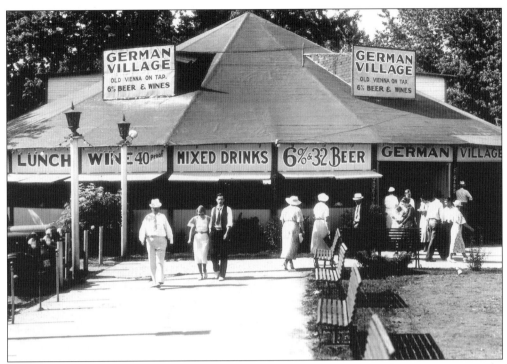

GERMAN VILLAGE. The German Village was originally built to house a very large merry-go-round.

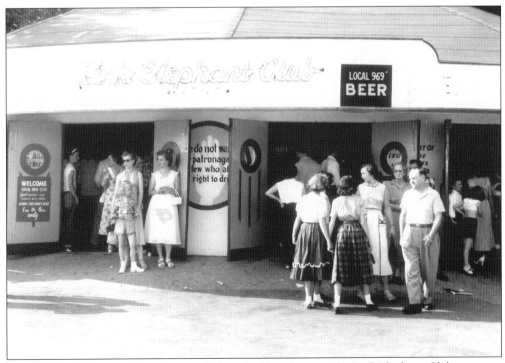

PINK ELEPHANT CLUB. This German Village building became the Pink Elephant Club.

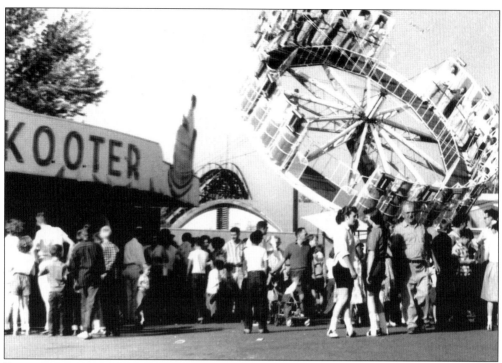

RIDES ALONG THE MIDWAY. The Skooter ride is on the left, and the Tilt-a-Whirl is on the right in this image.

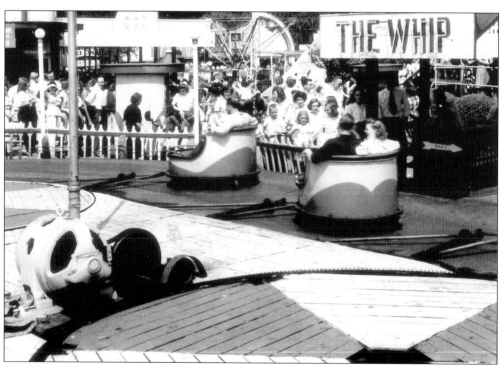

THE WHIP. This ride was located in front of the two rides above.

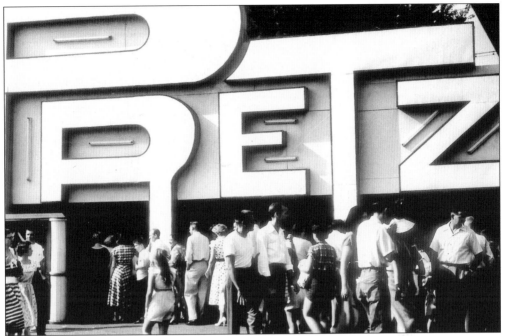

THE PRETZEL. At one time, this ride sat next to the Pink Elephant Club.

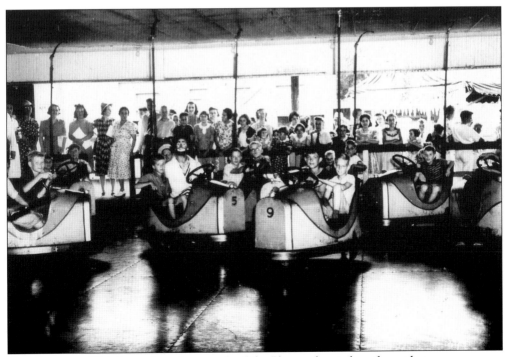

THE SKOOTER. This is another photograph of the Skooter located on the midway.

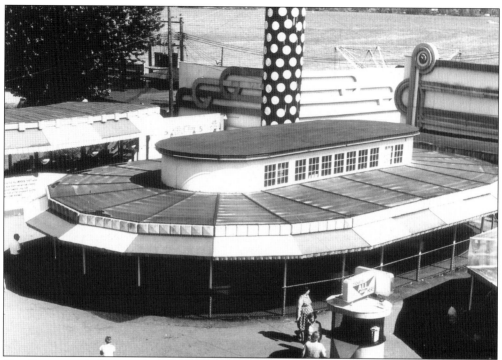

THE SKOOTER. A photograph of the ride from the air with the lake in the background is seen here.

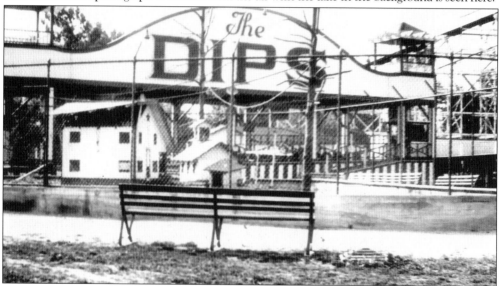

THE DIPS. This was a sensational coaster built on shore and over the lake. It was one of the steepest and fastest rides to be found in any amusement park in the country. Monkey Island is located in the foreground. A high chain-link fence surrounded a moat that was filled with water. The island was covered with monkeys, which were a great attraction for the park. One time, the monkeys escaped when the moat was being cleaned, and there were monkeys on the Dips, in the trees, and on Picnic Point. The park management called the Columbus Zoo and asked for help. They were told the monkeys were used to being fed so to just leave the gate open and they would come back. They did.

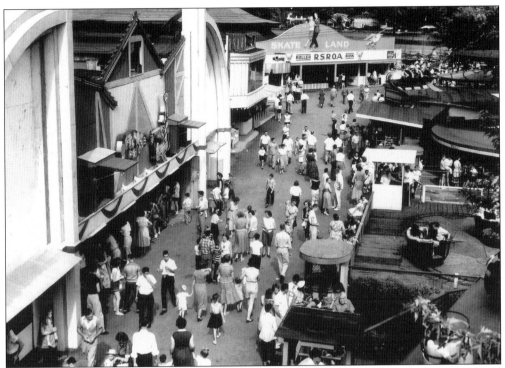

THE MIDWAY, LOOKING TOWARD THE SKATING RINK. This photograph was taken in 1956.

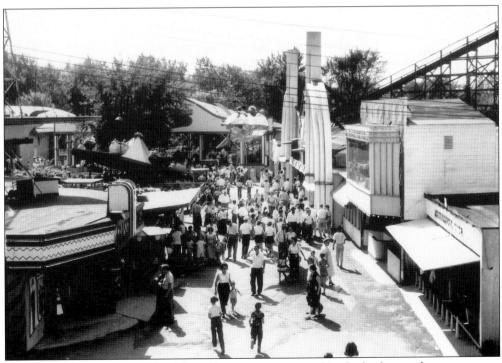

THE MIDWAY, LOOKING WEST. The roller coaster is pictured in the background.

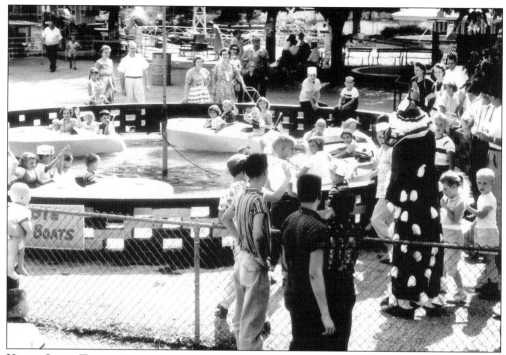

KIDDIE LAND TUBS OF FUN. Many children are seen enjoying Kiddie Land on a Sunday afternoon.

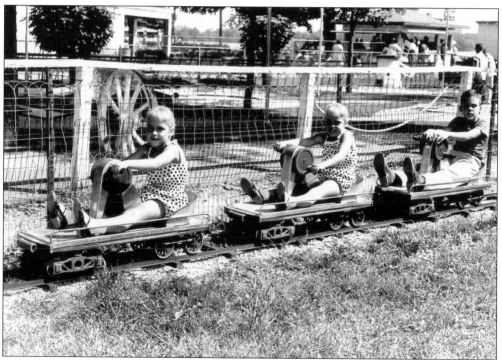

KIDDIE LAND HANDCARS. The author's son Sonny and twins Jane and Janet are seen riding the handcars.

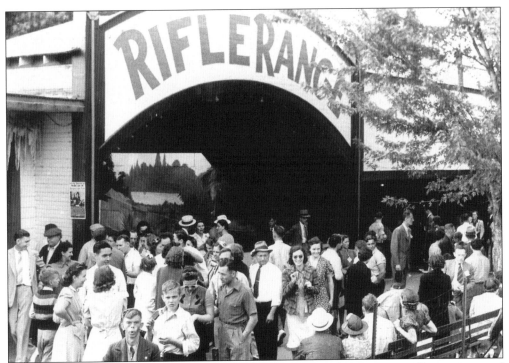

THE RIFLE RANGE. The rifle range featured automatic and pump-action Remington and Winchester rifles and moving targets.

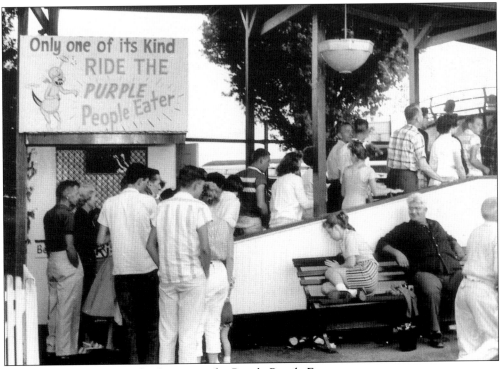

THE BUG. This ride was also known as the Purple People Eater.

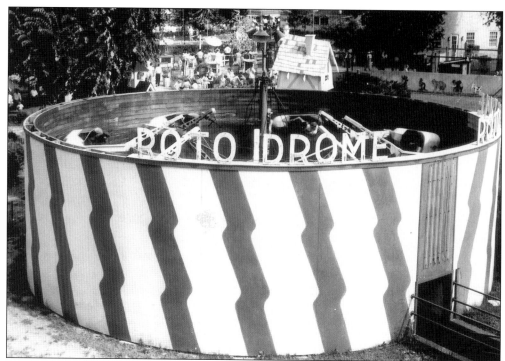

THE ROTO DROME. Passengers entered this ride by getting into a car, and centrifugal force kept the cars on the vertical wall.

THE BUG. This photograph shows the ride during a company picnic.

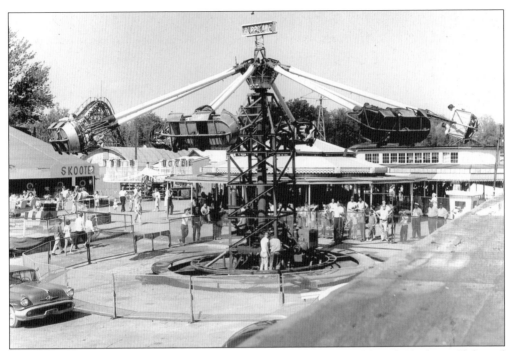

SCENE ALONG THE MIDWAY. The Skooter ride was located in the old Pink Elephant Club, and the roller coaster is in the background.

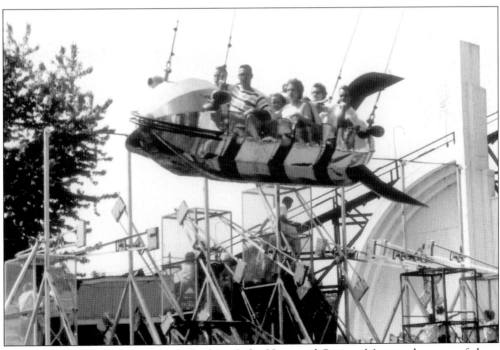

THE ROCKET SHIPS. The Greater Buckeye Lake Historical Society Museum has one of these ships restored and on display.

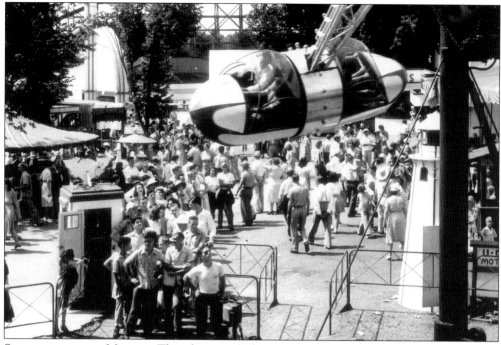

SCENE ALONG THE MIDWAY. This photograph shows an early Rocket Ship ride.

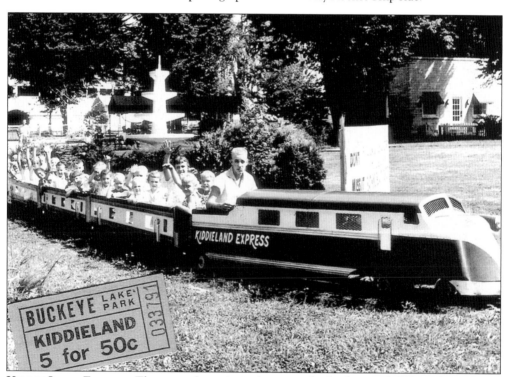

KIDDIE LAND EXPRESS. The water fountain is shown in the background. When the park was sold, the water fountain was kept and is now in the center of the Buckeye Lake State Park North Shore Ramps parking lot. Note the five rides for 50¢.

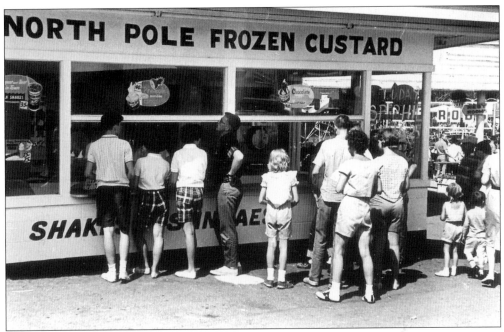

NORTH POLE FROZEN CUSTARD. This concession was owned by Morris Carlin, the brother of John Carlin Sr. who was the owner of the park.

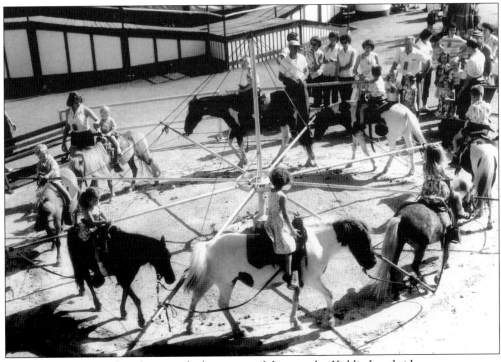

LIVE PONY RIDES. This photograph shows one of the popular Kiddie Land rides.

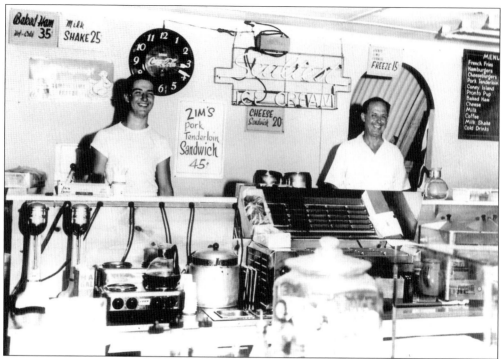

ZIMMER'S CONCESSION STAND. Sonny Zimmer, on the left, and his father Otho are pictured in their concession located on the waterfront.

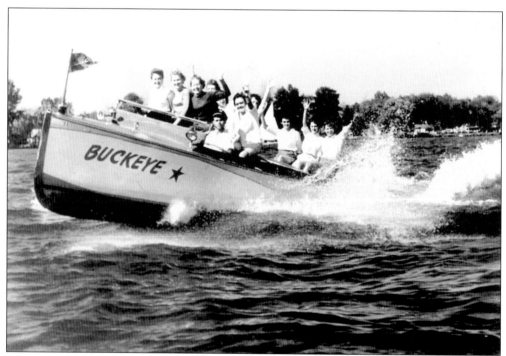

THE BUCKEYE LINE SPEEDBOATS. This photograph shows a happy group of girls spending an afternoon on Buckeye Lake.

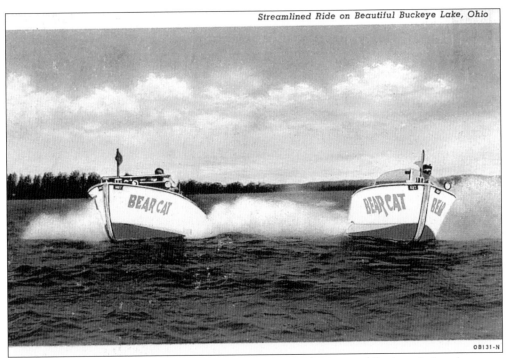

THE BEAR CAT LINE OF SPEEDBOATS. Owned by Jim Chapman of Buckeye Lake, these two boats were featured in a Hollywood movie. This photograph was taken at Buckeye Lake.

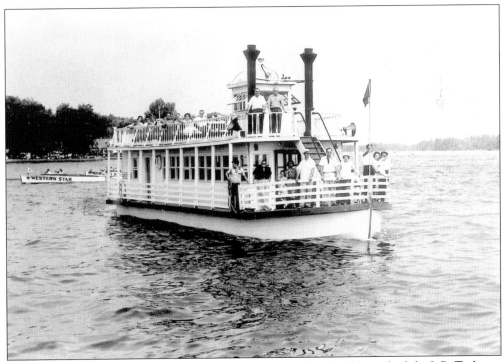

PADDLE WHEEL. The *Mary C. Carlin* was one of two paddle wheel boats built by J. B. Taylor.

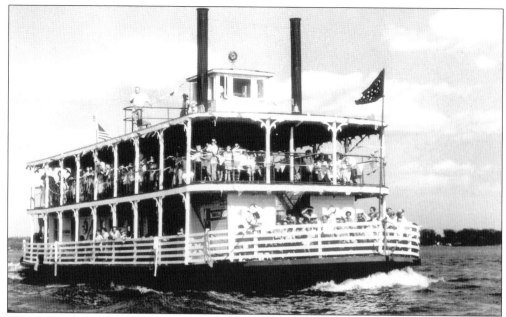

THE *J. B. TAYLOR*. This boat was built in 1956–1957 by Capt. Ed Taylor in the "old canal" at Millersport, on Buckeye Lake. It had a quarter-inch steel hull. The 14-foot stern wheel, which was 12.5 feet in diameter, was powered by a diesel motor. The boat had a ballroom with capacity for 300 passengers. It was named for Captain Taylor's two small granddaughters Jodelle and Becky.

DANCING ON THE *J. B. TAYLOR*. Many dances were held on the dance floor located on the lower deck of the *J. B. Taylor*.

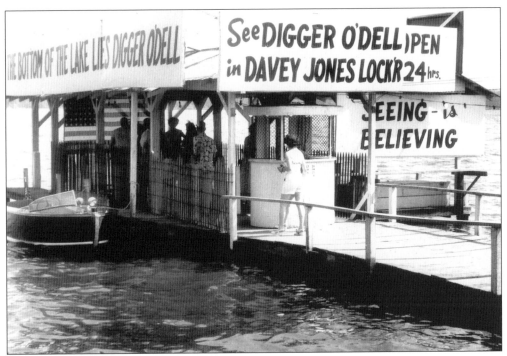

DIGGER O'DELL. You could see Digger O'Dell in Davey Jones Locker for the cost of only 25¢. The fellow was in a casket with a glass top, and there was a system set up so that you could talk to him. Supposedly he was buried under the water 24 hours a day; however, when the park closed at night, he was spotted in the Pink Elephant Club.

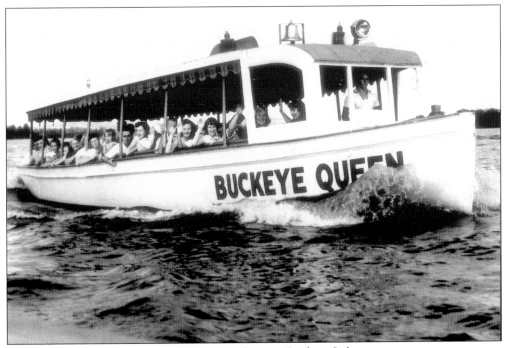

THE BUCKEYE QUEEN. This was a passenger boat on Buckeye Lake.

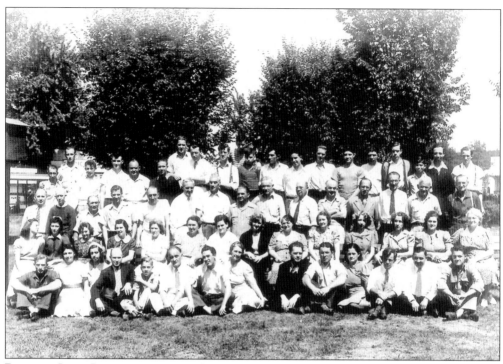

BUCKEYE LAKE PARK EMPLOYEES. This is a photograph of men and women who were owners or operators of park concessions.

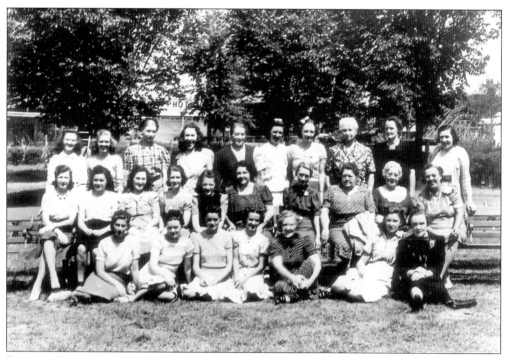

BUCKEYE LAKE PARK EMPLOYEES. Most of the ladies in this photograph were cashiers or owners of concessions in the park.

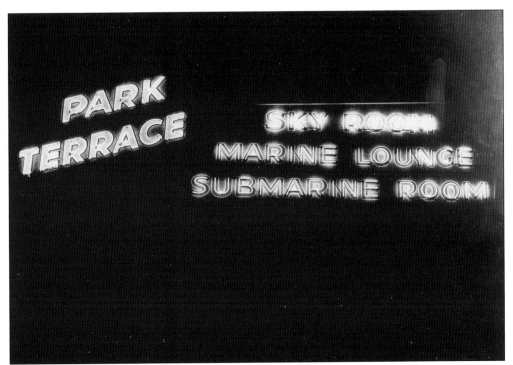

NEON SIGN ADVERTISING THE PARK TERRACE. Neon lighting was very popular throughout the park.

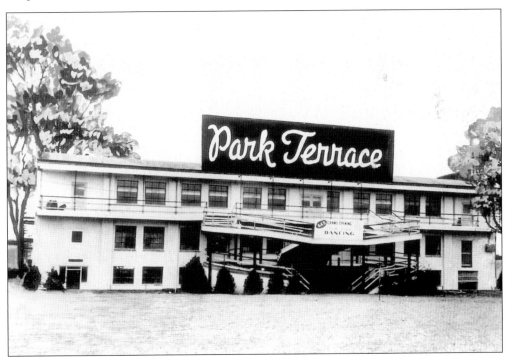

THE PARK TERRACE. The Park Terrace included the Sky Room, the Marine Lounge, and the Submarine Room.

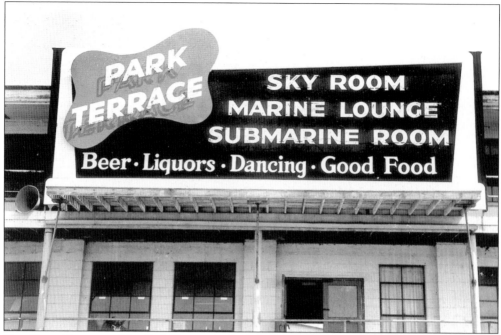

THE PARK TERRACE. The Park Terrace had a beautiful porch overlooking the lakefront above the Buckeye Lake Park Midway. It was the spot for all seasons—open, airy, and cool in summer, heated and snug in the winter.

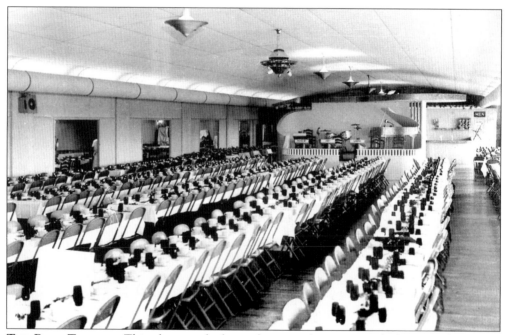

THE PARK TERRACE. This photograph shows the main dining room, looking south onto an open spacious mezzanine porch overlooking the lakefront. The magnitude of this room made it possible to accommodate very large groups. Tables could be arranged for large dancing crowds with dancers using the open porch for seating.

Tilt-a-Whirl. This ride was located next to the Pink Elephant Club.

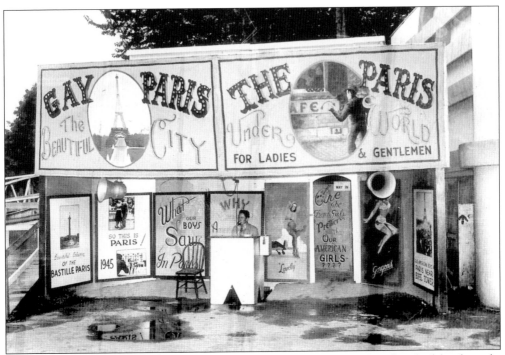

Funny Photograph Gallery along the Midway. This photograph gallery had four-by-eight sheets of plywood with funny pictures painted on the front. Patrons stuck their heads through a hole to have their picture taken.

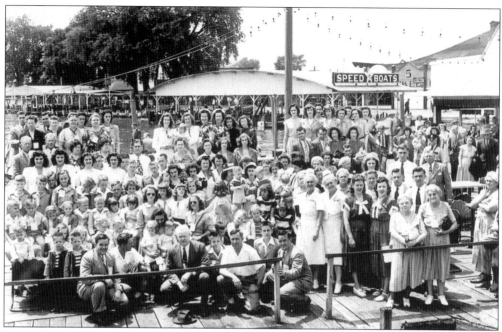

TWINS PICNIC. Twins came from all over the United States for this picnic. Prizes were given to the twins who traveled the farthest and the ones who looked the most alike.

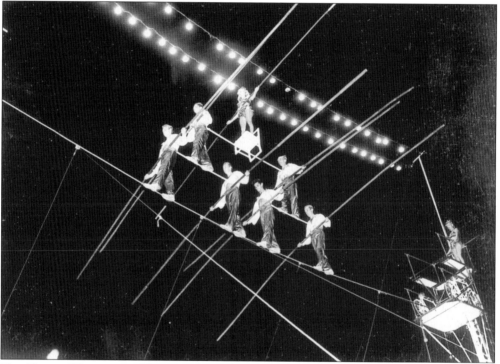

THE FLYING WALLENDAS. This was one of the many free acts that appeared in the park. They performed all over the world without any nets or safety devices.

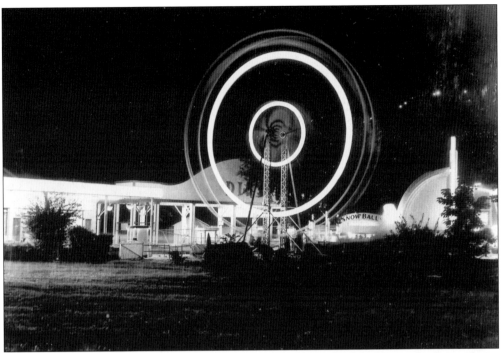

NIGHT VIEW OF THE PARK. This photograph is a time exposure of the Ferris wheel at night.

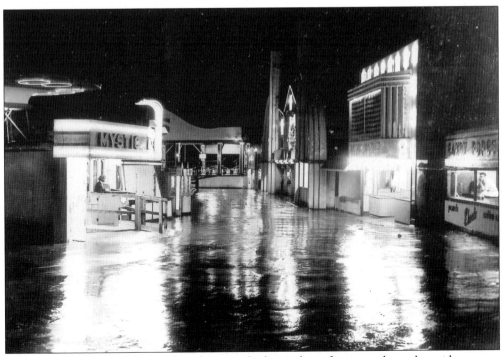

NIGHT VIEW OF THE PARK. This photograph shows the reflections along the midway on a rainy evening.

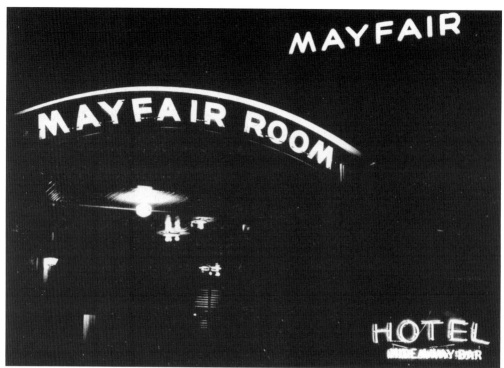

NIGHT VIEW ADVERTISING THE MAYFAIR ROOM. The Mayfair Room was located in the Lake Breeze Hotel.

LENNY DEE. Lenny Dee performed nightly at the Mayfair Room.

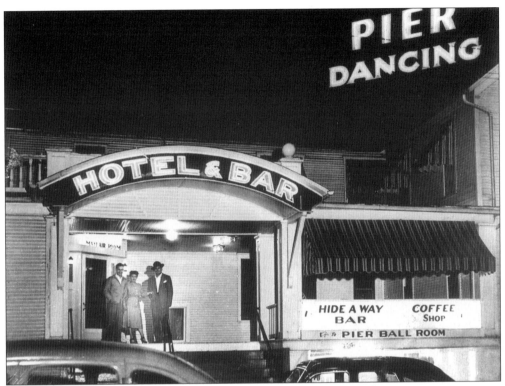

NIGHT VIEW. This is the rear entrance to the Lake Breeze Hotel.

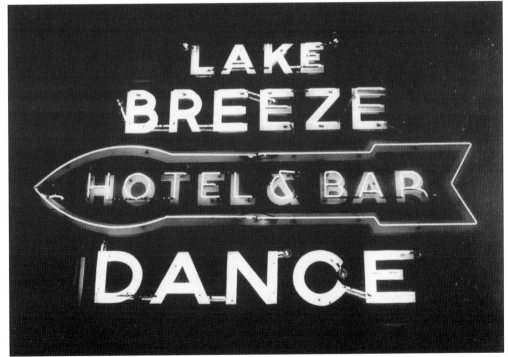

NEON LIGHTS. This photograph shows one of the many neon lights that appeared in the park.

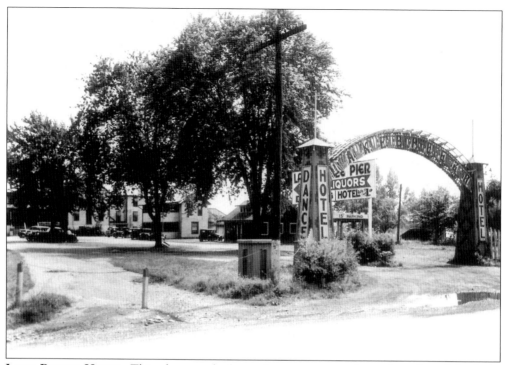

LAKE BREEZE HOTEL. This photograph shows the entrance to the parking lot of the Lake Breeze Hotel.

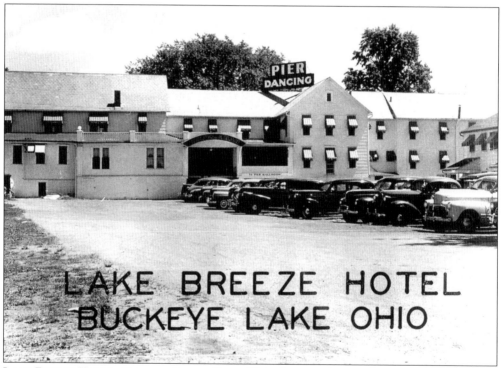

LAKE BREEZE HOTEL, BUCKEYE LAKE, OHIO. This photograph was taken in 1956.

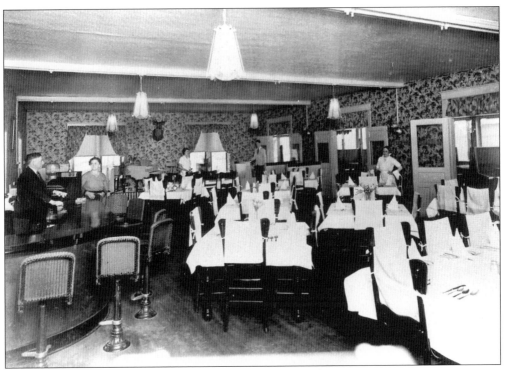

THE MAYFAIR ROOM. This is a look at the interior of the Mayfair Room.

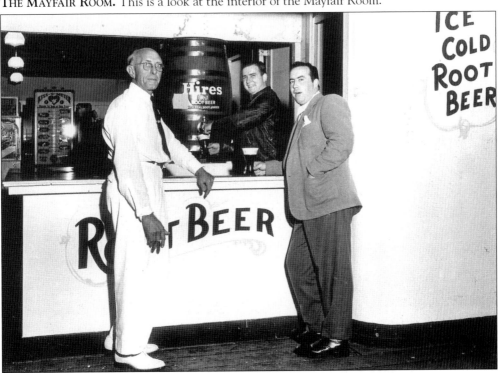

ROOT BEER STAND. This stand was located in front of the Lake Breeze Hotel. "Whitey" is on the left, Herb Ingram is in the center, and Jim Ingram is on the right.

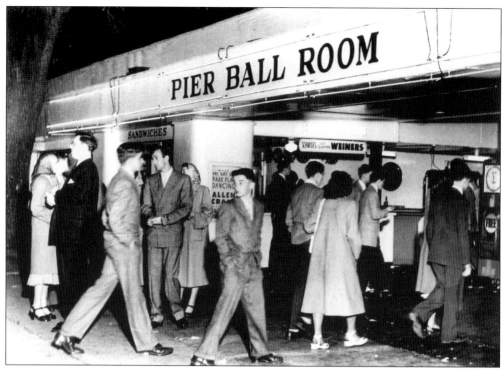

ENTRANCE TO THE PIER BALL ROOM. This is a photograph of the crowds entering the dance hall when one of the named bands was appearing.

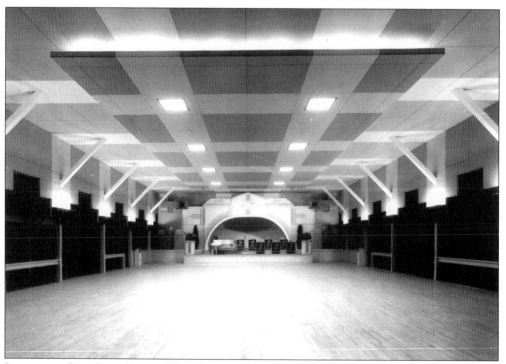

INSIDE THE PIER BALL ROOM. This photograph was taken in 1956.

GRATZIANO AND CARLIN RESTAURANT. This restaurant was located on the pier, which also held a Dodgem ride, merry-go-round, Ferris wheel, and fun house. In 1924, Gratziano and Carlin purchased the state lease for this property from the Dell Fisher Boat Line Company. The restaurant was located adjacent to the Lake Breeze Hotel.

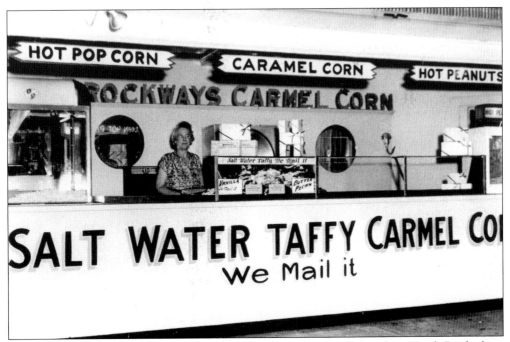

BROCKWAY'S CARMEL CORN CONCESSION. This concession was located on North Bank along the midway in front of the Mayfair Room, which was connected to the Lake Breeze Hotel.

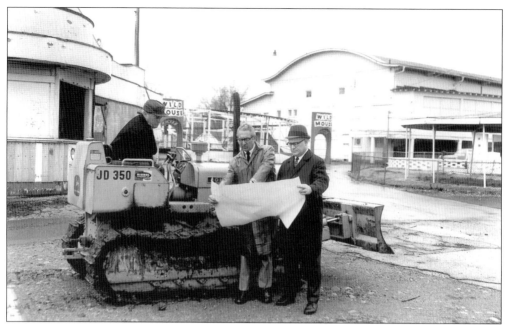

BUCKEYE LAKE PARK PURCHASED BY DIVERSIFIED. According to the *Advocate*, dated December 11, 1968, "A newly-formed amusement firm, Diversified Amusement Industries has purchased Buckeye Lake Park for nearly $1 million and plans to develop a top-flight amusement park and plush country music center." They sold stock but not enough to complete the deal. Also, they had a very bad year financially due to bad weather, and the park reverted back to John Carlin.

CHAIR LIFT RIDE. While Diversified had the park, they installed this Chair Lift ride, which carried riders from one side of the park to the other.

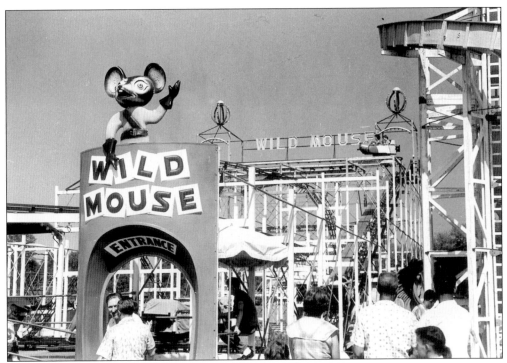

WILD MOUSE. Diversified also built the Wild Mouse ride.

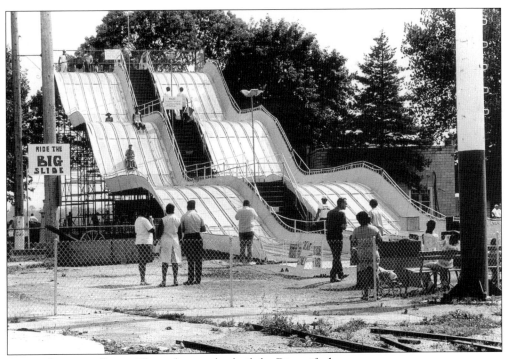

GIANT SLIPPERY SLIDE. This ride was also built by Diversified.

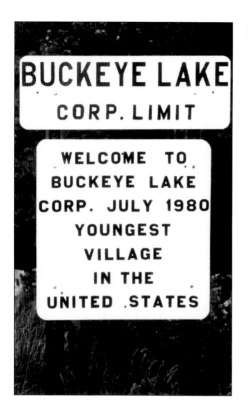

BUCKEYE LAKE VILLAGE. The village was incorporated in July 1980.

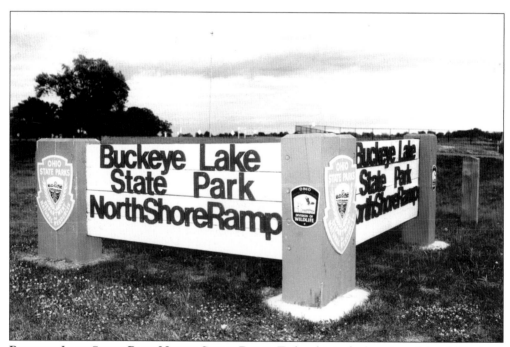

BUCKEYE LAKE STATE PARK NORTH SHORE RAMP. Today this is the location of the old Buckeye Lake Amusement Park.

Five

THE BIG BAND ERA, SKATE SHOWS, AND BEAUTY CONTESTS

The big bands were very popular. They brought huge crowds to the park. The two dance halls were always in competition with each other. They were owned by two different companies, and the owners were smart businessmen. They did not book two name bands on the same night in both dance halls. When either of the dance halls had a big-name band, the park, all the midways, both dance halls, and all concessions benefited from the huge crowds. During this time, the economy in the country was good. Employment was very good in this area. The dance crowd was what was referred to as the money crowd. They were a young, active group, which brought a lot of money to the park.

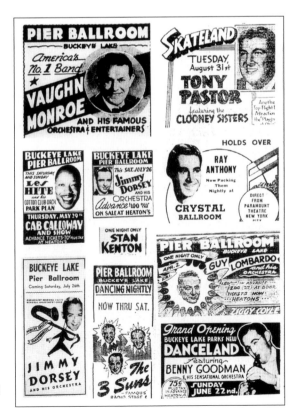

BIG BAND ADVERTISEMENTS. Many big bands appeared at Buckeye Lake Park.

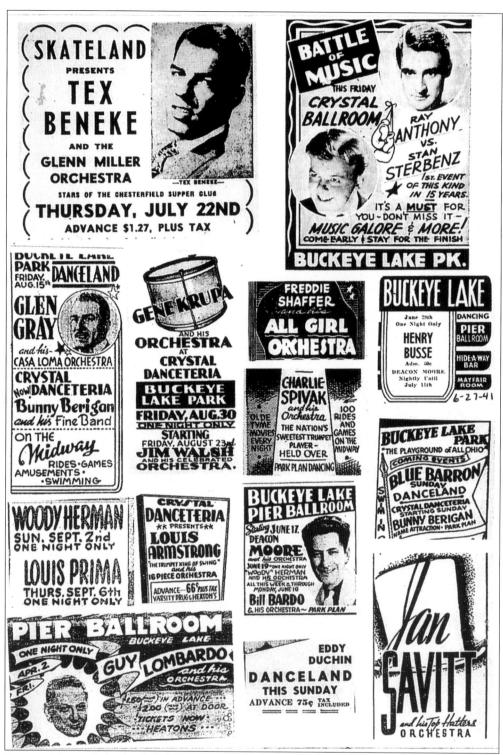

BANDS. Many of the big bands appeared at the Pier Ball Room, Skateland, and the Lake Breeze Pier.

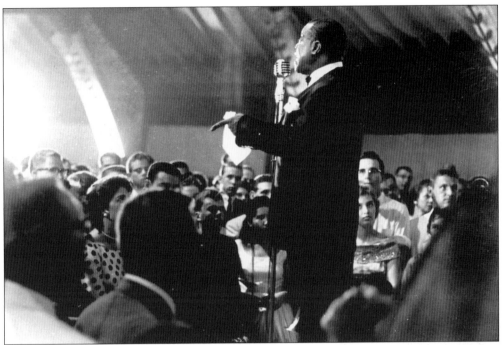

LOUIS ARMSTRONG. This photograph shows "Satchmo" performing in the skating rink at Buckeye Lake Park. When management expected a huge crowd, the dances were usually held in the skating rink.

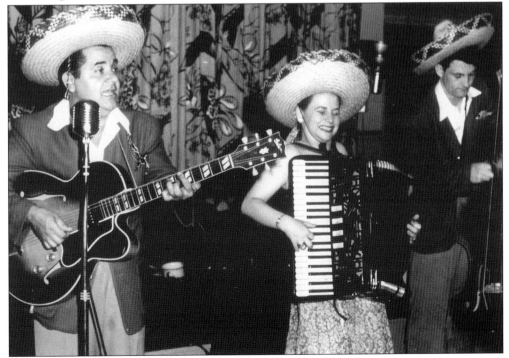

MITZI JOYCE TRIO. This trio performed nightly in the Mayfair Room of the Lake Breeze Hotel. Shown are Tony Sacco, Mitzi Joyce, and Marty Rowe on bass.

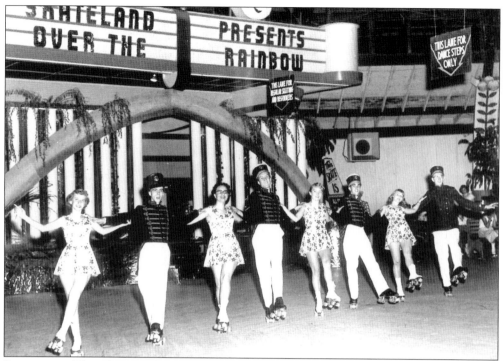

SKATELAND. This photograph shows one of the many skate shows, "Over the Rainbow," which were held in the skating rink at Buckeye Lake Park.

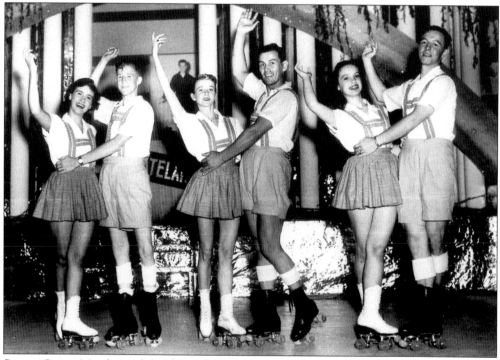

SKATE CLUB. Members of the skate club perform in one of the many productions presented at Skateland.

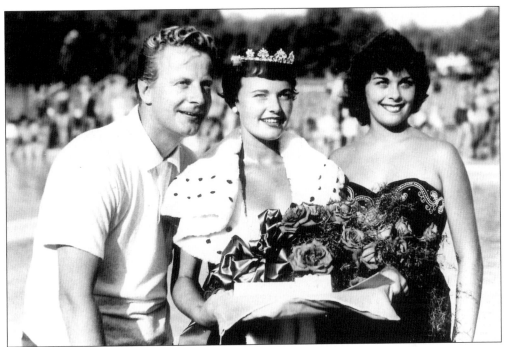

BATHING BEAUTY CONTEST. The *Columbus Sunday Star* sponsored bathing beauty contests in August of each year. This photograph is of Mary Ann Young, beauty contest winner.

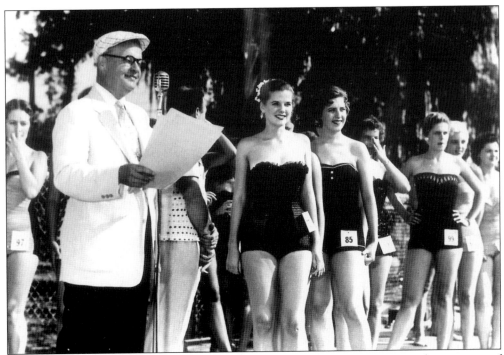

BATHING BEAUTY CONTEST. This photograph shows Irwin Johnson, master of ceremonies of the Columbus Sunday Star Beauty Contest. Johnson was called the Voice of WBNS Radio or was better known as the Early Worm.

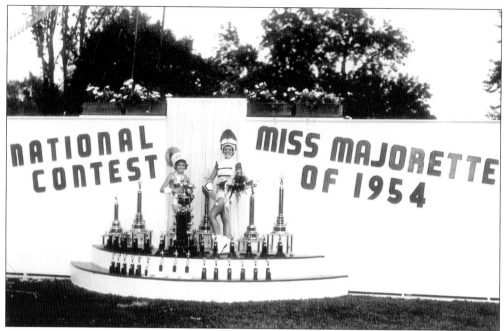

MAJORETTE CONTEST, 1954. Batons bring home trophies to these lovely winners of the first annual Miss Majorette Contest held Sunday, August 6, 1954, at Buckeye Lake Park.

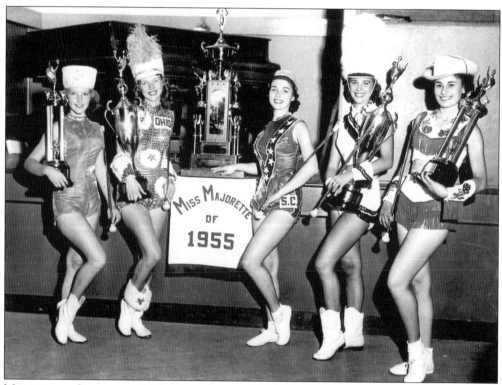

MAJORETTE CONTEST, 1955. This photograph shows the class winners of the National Miss Majorette Contest.

Six

FIRES, FLOODS, AND STORMS

Fires and storms caused much damage to Buckeye Lake Park during different periods of time. Floods throughout the years did not cause damage to the park but caused property damage to the village.

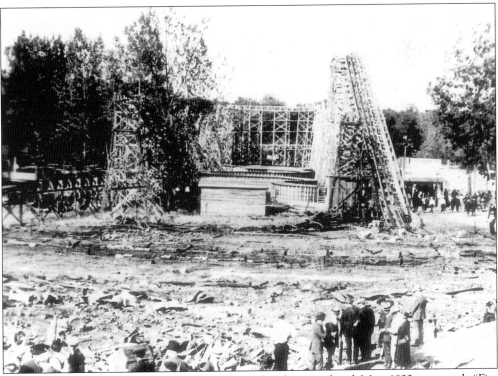

BUCKEYE LAKE PARK FIRE, 1922. The *Newark Advocate*, dated May 1922, reported, "Fire sweeps Buckeye Lake Park and razes heart of resort. Pool room, rink, and arcade buildings are destroyed. Loss near $100,000. Blaze starts at 5 a.m. at Smith Lumber Company." The heaviest loser was the Ohio Electric Company, which owned the property burned and the land on which it stood. The skating rink (the largest in Ohio) was totally destroyed, and damage was done to the machinery and cars of the Figure Eight ride. Note that at this time the roller coaster did not go out over Crane Lake. Concessions that were completely destroyed were the Brockway Pool Room, Nelson's Confectionery, the Shooting Gallery, the Penny Arcade, and Kockenbach's Confectionery.

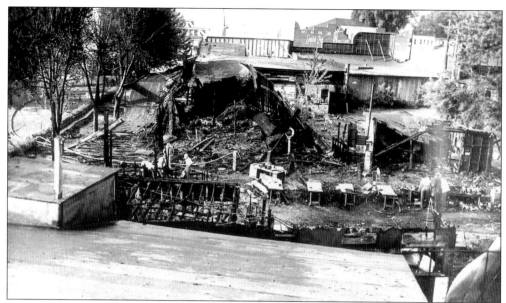

BUCKEYE LAKE PARK FIRE, 1947. Shortly after midnight, August 13, 1947, fire broke out in the Buckeye Lake Park Midway and flared dangerously through the night until brought under control. The blaze spread swiftly through the wooden concession buildings. The roaring flames moved through the Greyhound Races, Goldsmith Shop, Sportland Horse Race, Penny Pitch, Cat Rack, Skee Ball, the Shooting Range, and part of the North Pole Frozen Custard stand.

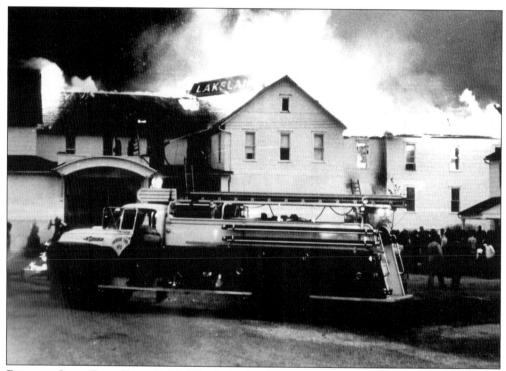

BUCKEYE LAKE PARK FIRE, 1966. The *Columbus Citizen-Journal* dated Saturday, November 19, 1966, stated, "Fire Rips Buckeye Lake Hotel" A $75,000 loss was estimated.

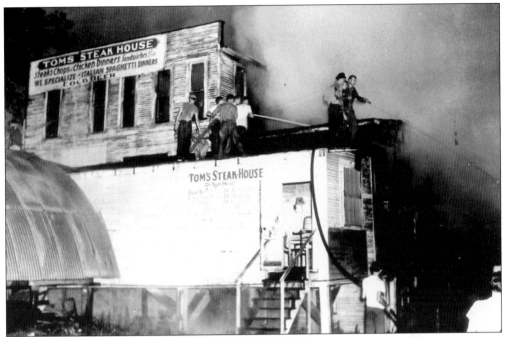

RESTAURANT FIRE. This is the result of Tom's Steak House restaurant fire at Buckeye Lake.

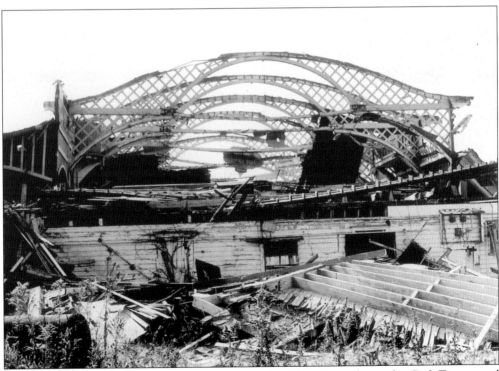

FIRE ON PIER. On November 24, 1970, a fire started on the piers and spread to Park Terrace and destroyed the Sky Room, Marine Lounge, and Submarine Room.

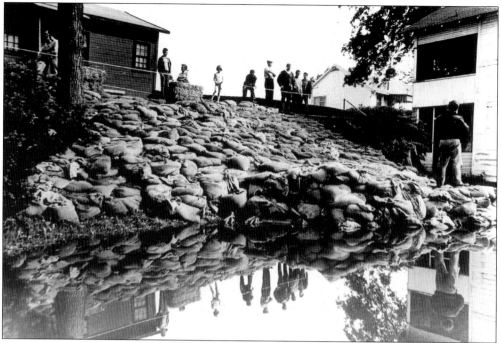

FLOOD, 1968. Workers are seen sandbagging threatened dikes at Buckeye Lake in May 1968.

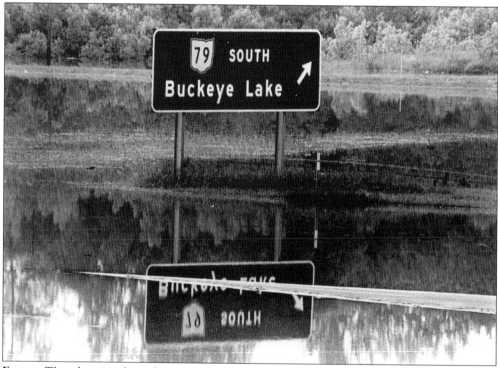

FLOOD. This photograph is of Interstate 70 at the Route 79 exit when underwater.

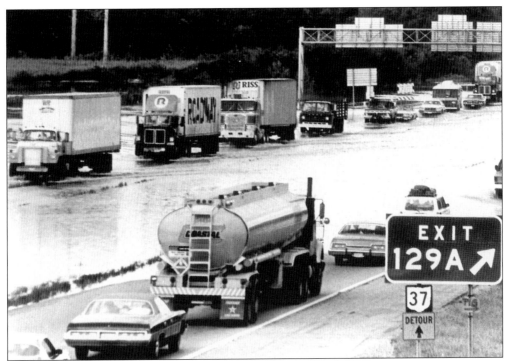

FLOOD AT BUCKEYE LAKE EXIT 129A. This photograph shows flood waters over Interstate 70.

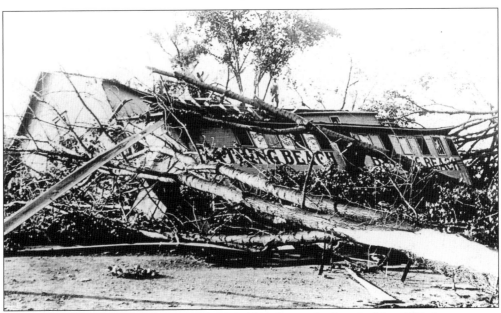

STORM. A tornado completes the work of the fire that took place in May 1922. It swept over Buckeye Lake Park, bringing death and destruction on Sunday, June 11, 1922. The *Newark Advocate* reported, "Sweeping a broken, freakish path, a cyclone which broke at Buckeye Lake Park Sunday afternoon at 5 o'clock, took a heavy toll in death and property loss." The big bathhouse owned by the Buckeye Bathing Company and operated by John Nelson was blown over. Also destroyed were the Canals of Venice and the miniature train ride that circled Crane Lake.

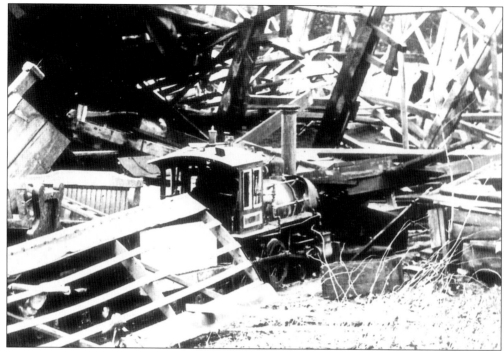

STORM WRECKAGE. This photograph shows the wreckage of the roller coaster. In the foreground, one can see the Little Train, which was a ride that completely circled Crane Lake.

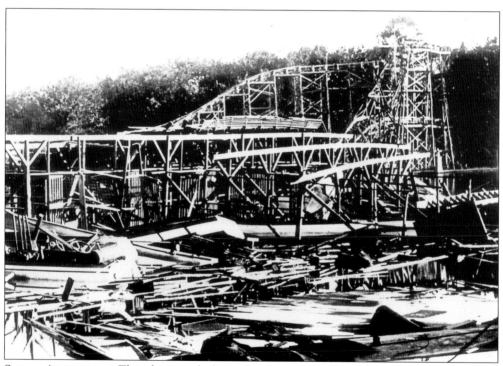

STORM AFTERMATH. This photograph shows the destruction of the roller coaster.

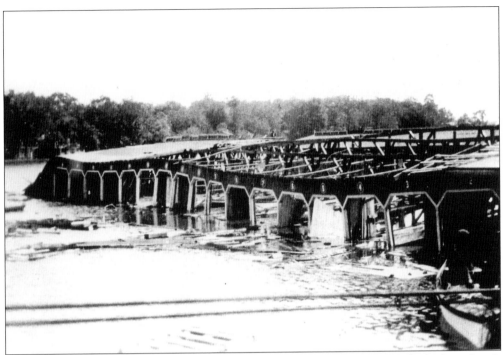

STORM. Cone-shaped clouds twisted in their fury. The boathouse opposite the bathing beach was damaged along with about 50 motorboats.

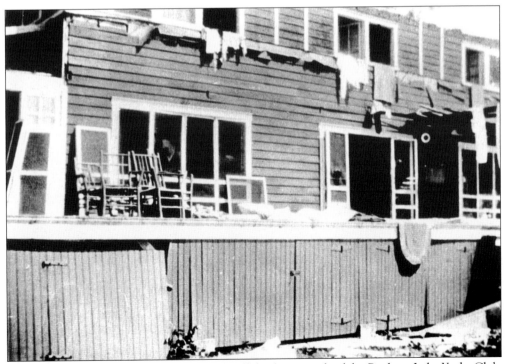

STORM, 1928. The June 1928 tornado tore off the front porch of the Buckeye Lake Yacht Club. Half a dozen yachts sank or were partially wrecked.

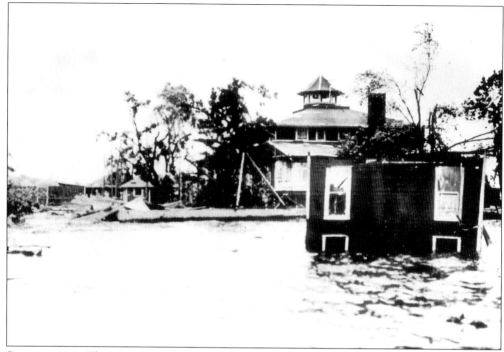

STORM, 1928. The 1928 tornado lifted three cottages completely off their foundation and set them in the lake in front of the Buckeye Lake Yacht Club.

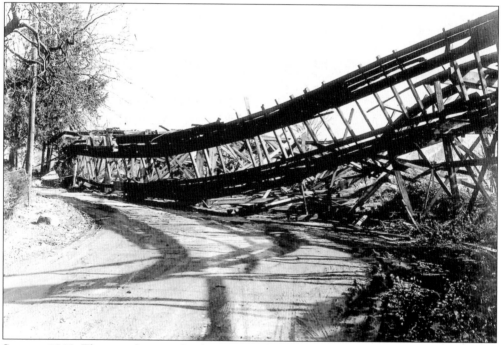

STORM, 1966. This is a photograph of a portion of Buckeye Lake's elderly roller coaster, which was sent downward into the water when heavy winds struck the park area about noon on Thursday, November 11, 1966.

Seven

CELEBRATIONS AND ACTIVITIES AROUND THE LAKE

The amusement park is gone, but there is still a beautiful lake. Among the current celebrations and activities every year are the Fourth of July boat parade and fireworks, an antique wood boat show featuring Chris Craft Boats sponsored by the Buckeye Lake Yacht Club, and SST60 and SST120 Tunnel Boat Class races, held in the summer. In August, the Buckeye Lake Civic Association has a tour of homes on the lake, and in October, the Buckeye Lake Yacht Club holds its Snow Ball Regatta. When the lake freezes over, ice fishing and motorcycle racing takes place.

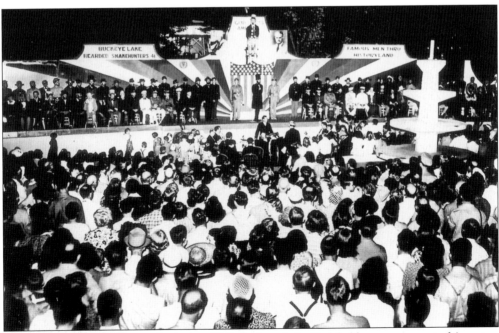

HEROES THROUGH HISTORY. In August 1941, Buckeye Lake Park held a great pageant of America. It was titled Heroes Thru Historyland. There were living portraits of Abraham Lincoln by Maurice Rice, Little Phil Sheridan by C. S. Brown, Ulysses S. Grant by Eugene Fitch, and Gen. William Sherman by John Dowie. There were over 200 famous characters and a 35-voice male choir. All characters were depicted by the Bearded Snake Hunters.

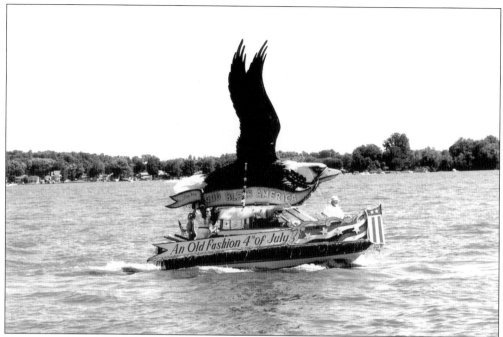

FOURTH OF JULY BOAT PARADE. Each year, there is a theme for the annual Fourth of July boat parade, and in the year pictured, it was An Old Fashioned Fourth of July.

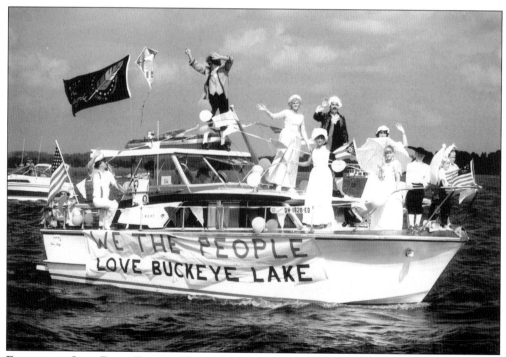

FOURTH OF JULY BOAT PARADE. One of the entries in the parade was titled "We the People Love Buckeye Lake."

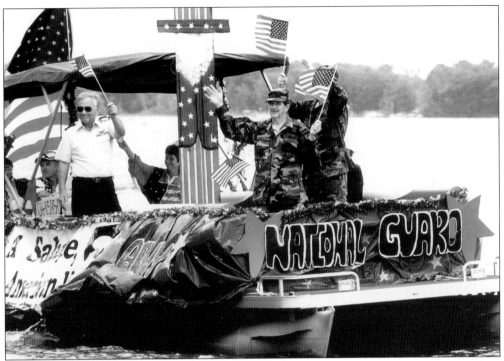

FOURTH OF JULY BOAT PARADE. The National Guard entered this patriotic float.

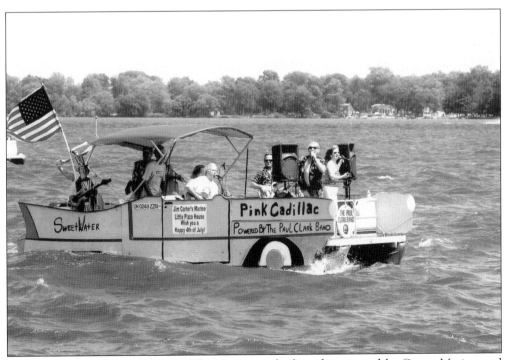

FOURTH OF JULY BOAT PARADE. This entry was built and sponsored by Carter Marine and featured the Paul Clark Band.

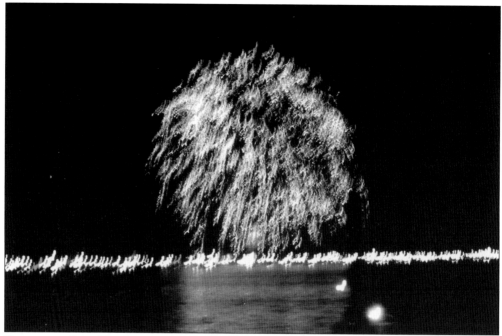

FOURTH OF JULY FIREWORKS OVER BUCKEYE LAKE. This photograph shows the reflection of the fireworks on the lake. At the bottom of the photograph, there can be seen the reflection of the hundreds of boats that come to the lake to watch the fireworks fly out over the water.

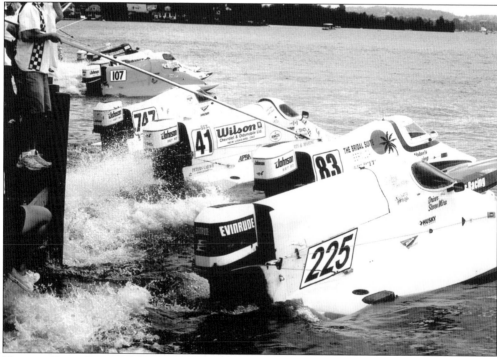

TUNNEL BOAT RACES. SST60 and SST120 Tunnel Boat Class racing is held each summer at Buckeye Lake.

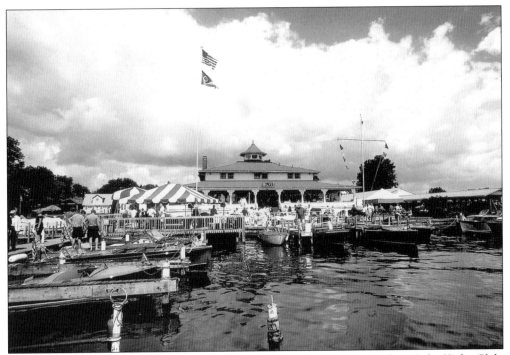

ANTIQUE WOOD BOAT SHOW. The Wood Boat Show is held at the Buckeye Lake Yacht Club. Each August, antique wood boats are brought to the lake from all over the country to be on display.

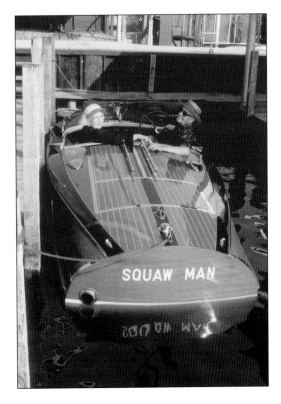

SQUAW MAN. This is an antique Chris Craft boat owned by William "Bud" Sayre and his wife, Zenna.

119

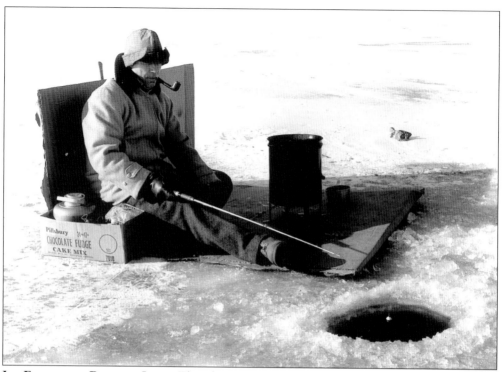

ICE FISHING ON BUCKEYE LAKE. This photograph was taken in 1956.

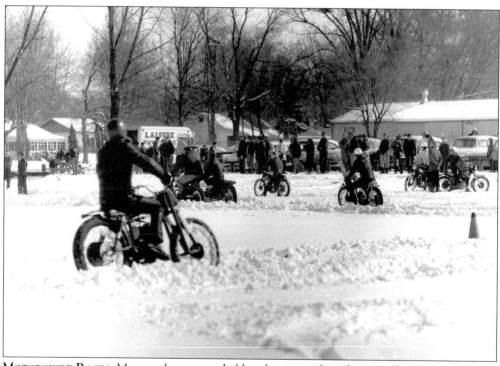

MOTORCYCLE RACES. Motorcycle races are held each winter when the ice is frozen on the lake.

Eight

BUCKEYE LAKE TODAY

Buckeye Lake has been a popular vacation spot for many years and today still offers many recreational opportunities. There is boating on the 3,000-acre lake designated as an unlimited horsepower lake. Buckeye is also popular for waterskiing. Public swimming areas are located at Fairfield Beach and at Brooks Park on the south side of the lake. Beaches are open from Memorial Day to Labor Day. Fishing is very popular as anglers enjoy catches of perch, bluegill, crappie, largemouth bass, and channel and bullhead catfish. The summer cottages around the lake have been converted to beautiful homes that are enjoyed year-round.

AN INTRODUCTION TO BUCKEYE LAKE, 2005. Churches and organizations in the village of Buckeye Lake are seen here.

PHOTOGRAPHS OF NEW AND VARIED BUSINESSES NOW LOCATED AT BUCKEYE LAKE. Here are more of the current businesses located at Buckeye Lake.

BANBURY CROSS
BRITISH FOOD

W J D's
Hair Design
& Nails

LEE'S
Famous Recipe Chicken

LAKE DRIVE-THRU

North Pointe
Cove
Apartments

MORE BUSINESSES. Pictured here are many of the signs that advertise current businesses in Buckeye Lake.

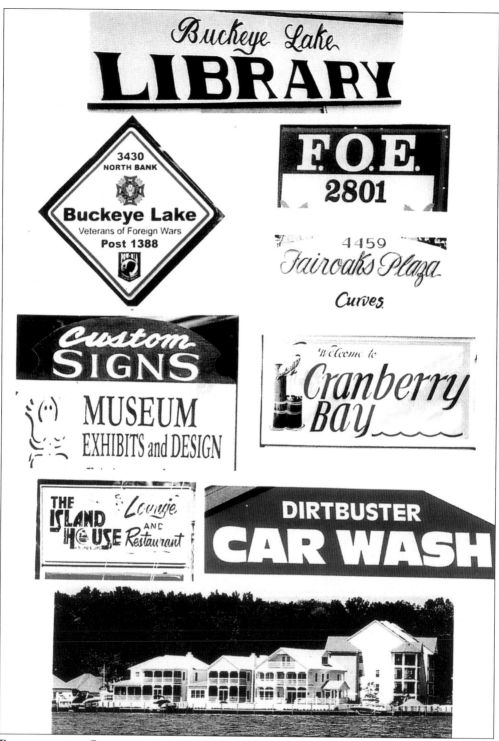

BUSINESSES AND ORGANIZATIONS AROUND THE LAKE. The reader might refer to top photograph on page 58 to see the Blue Goose area as it appeared in 1910 and compare it to the bottom photograph on this page.

Nine

TOWNS AROUND THE LAKE

This book covers the same area as that of the Greater Buckeye Lake Historical Society: on the north side, the National Road (Route 40) from Luray east through Hebron to Jacksontown, then south on Route 13 to Thornport and Thornville and west on Route 204 to Millersport, then north on 37 back to Luray. Today most people think of Luray as being just a wide spot in the road. At one time, it had its own post office, an elementary school, and several businesses. It was also the birthplace of Mary Hartwell Catherwood, who was born December 16, 1847. She was a school teacher by the age of 12. She was also an accomplished poet and writer. She moved to Chicago and had many books published, some of which were made into stage plays. The play *Lazarre* was made quite famous by Otis Skinner. Luray also was the site of the 1936 National Corn Husking Contest, where over 160,000 farm folk traveled to the Clayton Oyler Farm near Hebron in Licking County to witness the championship. A few miles east along the National Road was Hebron, which was sometimes referred to as the crossroads of Ohio because at that point the National Road crossed the Ohio Canal. In Jacksontown, the Larson General Store was located at the corner of Route 13 and the National Road and at one time had been a stagecoach stop. Thornville became a town in 1811. In the fall of 1831, the canal in Millersport was filled with water from the reservoir, and the first boats started downstream. The first boat to travel through Millersport on the Ohio Canal was called the *Red Rover*. Each September, the annual Sweet Corn Festival is held and sponsored by the Millersport Lions Club.

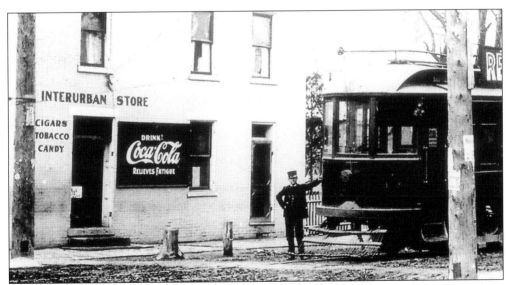

INTERURBAN STATION AT HEBRON. The interurban car shown is like one the author rode to Hebron School in first and second grades.

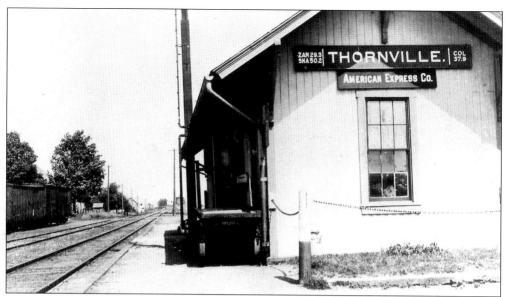

RAILROAD STATION LOCATED AT THORNVILLE. The Baltimore and Ohio Railroad ran from Newark along the eastern shore of Buckeye Lake to Thornville and points south.

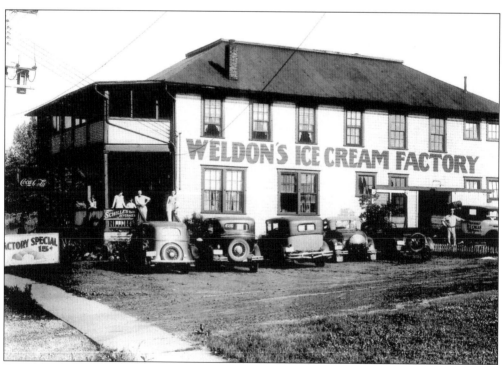

WELDON'S ICE CREAM FACTORY, MILLERSPORT. Note the sign "Factory Special—7 dips for 15¢."

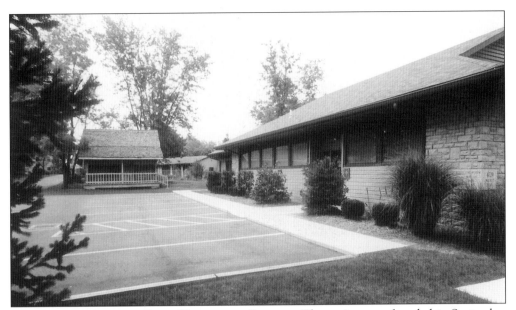

The Greater Buckeye Lake Historical Society. The society was founded in September 1995. Land for the building was donated by Marge and Jack Goodin. Fred E. Wright & Associates, Inc. was architect and planner, and George "Mac" Wood was in charge of construction. Groundbreaking took place in 1997. Also in 1997, a log cabin donated by Betty and Phil Clark was moved to the site and rebuilt. The grand opening was in May 1998.

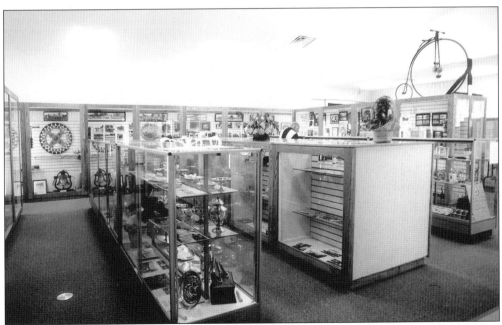

Inside the Greater Buckeye Lake Historical Society. Buckeye Lake Park was known throughout Ohio as "the Playground of Ohio," and a large part of the museum contains photographs, restored amusement rides, and one-of-a-kind artifacts. There is historical material from all localities in the Buckeye Lake region, including the towns of Millersport, Thornville, Jacksontown, Thornport, and, of course, Buckeye Lake.

CHANCE BROCKWAY WITH HIS DAUGHTER SONDRA BROCKWAY GARTNER, WHO HELPED MAKE THIS BOOK POSSIBLE. Chance Brockway graduated from Hebron High School in 1936 in one of the smallest classes ever. There were 12 people in his class, and their motto was "quality not quantity." He enrolled at Ohio Sate University in the fall of 1936, majoring in chemical engineering. In the spring of 1937, he became manager of the Buckeye Lake Bus Station Restaurant. He married Donna Jean Roley, June 5, 1942. He went to work at the Ralston Steel Car Company, which had a government contract building coal cars for Russia as part of the government lend/lease program. In 1942, he entered the army and was placed in the 396th Air Base Squadron of the Air Force in the Aleutian Islands. When he was discharged from the army, he enrolled in the Progressive School of Photography in New Haven, Connecticut, which started his career in photography. He was employed for 16 years at North American Aviation, Columbus Division, Columbus, Ohio. He also worked five years as a photographer at Ohio State University Medical Department photographing operations. During that time, he also served as president of the first Lakewood High School Board of Education and was assistant fire chief at Buckeye Lake for 12 years. He also had a business as a freelance sports photographer and photographed over 500 NFL football games, seven Super Bowls, and almost all Ohio State University football, basketball, and miscellaneous sports events from 1956 to the late 1980s. This is a *Beacon* photograph by Kim Garee.